IMAGES
of America
SAFETY HARBOR

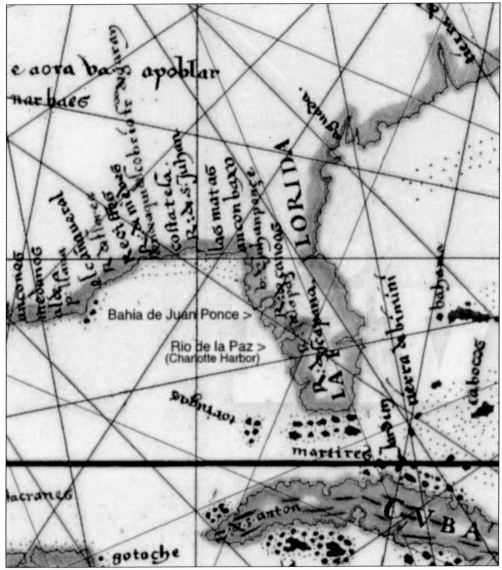

Recently rediscovered Spanish maps reveal a Bay of Juan Ponce at the head of Old Tampa Bay. For three months in 1521, Juan Ponce de Leon established the first European colony in today's United States on the shores of Tampa Bay, making Safety Harbor extremely relevant to the story of Florida. (Courtesy of James E. MacDougald, author of *The Maps That Change Florida's History*.)

ON THE COVER: In 1925, during the Florida land boom, Safety Harbor's population increased along with considerable construction of new homes, hotels, and businesses. These were busy times for the young city. Four of Safety Harbor's five commissioners are seen here in a moment of friendly conversation at the waterfront. From left to right are C.A. Samuelson, George McRory, mayor pro tem E.A. Risbeck, and J.H. Blakely. (Courtesy of Safety Harbor Public Library.)

Laura Kepner

Copyright © 2022 by Laura Kepner
ISBN 978-1-4671-0852-2

Published by Arcadia Publishing
Charleston, South Carolina

Printed in the United States of America

Library of Congress Control Number: 2022936015

For all general information, please contact Arcadia Publishing:
Telephone 843-853-2070
Fax 843-853-0044
E-mail sales@arcadiapublishing.com
For customer service and orders:
Toll-Free 1-888-313-2665

Visit us on the Internet at www.arcadiapublishing.com

For Chris, with love and fond memories of August 2008, when we arrived in Florida and felt pulled by some unexplained force toward a charming little city on the bay.

CONTENTS

Acknowledgments		6
Introduction		7
1.	Land Grants and a New Century	9
2.	Land Boom to Great Depression	41
3.	The Harbor's Heyday	69
4.	Mid-Century to Millennium	99

ACKNOWLEDGMENTS

Thank you to friends, neighbors, and strangers who supported my love of local history through conversations, photographs, and time.

Safety Harbor Public Library director Lisa Kothe, Reference and Adult Services manager Mallory Cyr, and Adult Services librarian Jarrett Trezzo deserve an old-fashioned parade for all they do for our community. Jarrett was a treasured resource throughout this project.

Heritage Village museum specialist Patricia Landon helped me mid-pandemic via email and in person, even during limited hours.

Betty Joe "B.J." McMullen's flower shop doors were open whenever I needed her memories, and she was able to bring a few people back to life for me through her photographs.

Many others provided photographs, identification of people, and stories that make up much of this book: Holly Apperson, Richard Aunspaugh, Melanie Kramer Brown, Lou Claudio, Jean Campbell Creamer, Ray Duke, Elizabeth Faubert, Sherri Glassner, Helen Gray, Kelly Griffin, Mick Jameson, Marilyn Kirkpatrick Halsey, Jacqueline Hayes, Danny Hill, Janet Hooper, Nyla Jo Hubbard, Logan Lewkow (Florida Sheriffs Association), Jacqui Linder, author Jim MacDougald, Donna Mack, Jewell McKinnon, David Nichols, Nadine Nickeson, Valerie Petree Nolte, Don Peer, Mema Ponds, Gracine Reed, Hildegard Røvde, Charles Russell III, Shannon Schafer, Jimmy Sever, Matt Spoor, Aaron Stewart, Terrie Thomas, the late Julie Wand, Col. Harry and Jacqueline Williams, Cheryl Williams, and the I Grew Up in Safety Harbor Facebook group.

I offer a nod to the anonymous people, past and present, who donated photographs and documents to the museum, library, and Heritage Village.

Huge appreciation goes to fellow Safety Harbor Museum board members, with a special shout-out to Scott Anderson, who proofed dates and details, and Heather Hildick, who helped haul heavy boxes of history from storage and then helped put them back.

I appreciate title manager Caroline Vickerson and the team of professionals at Arcadia Publishing for their communications and encouragement, and special thanks to editor Jim Kempert for his questions and detailed edits through the final stage. Thanks also to senior title manager Caitrin Cunningham.

And then there is my writers group, who continuously help me improve: Amy Bryant, Nancy Bruckner, Barbara Finkelstein, Warren Firschein, Carrie Granato, Deb Klein, Laura McCullough, and Joe Richardson.

To my family, I will love you way beyond our own history.

INTRODUCTION

I'm so glad I got to live my life here, in all of Safety Harbor's quaintness.

—Julie Wand, 1958–2021

Long before the First Peoples fished in Tampa Bay, hunted game, raised families, and created mounds that have survived for centuries, mythical-like mammals roamed freely. Skeletal remains of sloths as tall as houses, armadillos as big as sedans, tiny three-toed horses, hornless rhinos, humpless camels, and fierce saber-toothed cats prove such animals populated Florida's early landscapes.

This area's recorded history dates to the early 16th century. Safety Harbor has long claimed Hernando de Soto as the first European to step foot here—the one whose words were supposedly captured with quill and parchment as he gave the shoreline its name: Espiritu Santo Springs, meaning "Springs of the Holy Spirit." While the romance of the story was a great marketing tool for early developers, it is unlikely the Spanish explorer actually landed here.

Jim MacDougald's recent rediscovery of two rare Spanish maps suggests that Safety Harbor deserves an important role in Florida's history. These maps show the place where the first governor of La Florida, Juan Ponce de León, likely established a settlement, and that it occurred in Safety Harbor. Panfilo de Narvaez landed at Tampa Bay in 1528 and found several crates—the remnants of that settlement. He and all but four of his men perished during the expedition. One survivor, who until rescued had been enslaved by the Tocobaga, would later document various descriptions of the Indigenous people, their communities, burial customs, and culture.

In 1567, warring Tocobaga and Calusa Indians were visited by Pedro Menendez de Aviles, who negotiated a peace treaty between them at a Tocobaga village and, yes, in Safety Harbor!

Cuban fishermen were likely the only visitors to Tampa Bay over the next century, and the influence of the Tocobaga declined. They may have integrated with other tribes and migrated north, or perhaps they disappeared for other unknown reasons.

In 1821, Florida was purchased from Spain and became a US territory. The Pinellas Peninsula was vastly unpopulated until the Armed Occupation Act of 1842, when Odet Philippe claimed 160 acres along the most beautiful part of what was then the Worth's Harbor shoreline, now Philippe Park. The names of several pioneers who settled and survived the heat, difficult soil, mosquitos, and wildlife are memorialized through many local street names: McMullen-Booth, Bailey, Philippe, Tucker, Washington, Woodell, and likely more. But who were they, and what contributions did they make to Safety Harbor's history? Consider the Baranoff Oak, the magnificent grand tree in front of the library. That too was named for someone important whose life impacted our history and helped to make Safety Harbor what it is today: a wonderful place to spend a week or a lifetime.

While the images throughout this book represent almost two centuries of Safety Harbor's more recent history, some stories have not been told, but only because history is selective. Whether this is due to scattered documentation in newspapers or rare personal family stories told to only a few descendants, the following photographs are intended to preserve the collective story of struggles and triumphs of all the people who helped to build and mold the town that so many love, thanks to a rich and diverse history connecting the present to the deep, sandy roots of Safety Harbor's past.

One

LAND GRANTS AND A NEW CENTURY

*When you're on Penobscot
or on the Ada May,
don't forget that Green Springs Inn
is just a little way.*

—Carrie L. Hall, 1907

The people who migrated and settled along the bay and surrounding areas, now Safety Harbor and Oldsmar, had ties to the military base, Fort Brooke, throughout the Second Seminole War. The base was in Tampa, just across the bay.

Odet Philippe, the first non-native settler to the Pinellas Peninsula, had done business at the fort and was likely already familiar with the 160 acres he claimed in the Armed Occupation Act of 1842. The "healing waters" and the beautiful waterfront land, which included mounds created hundreds of years before by Indigenous peoples, was known to Fort Brooke's soldiers.

Another pioneer, James P. McMullen, left his Georgia home at the age of 18 to head south to a climate better suited for healing and to avoid infecting his parents and siblings with tuberculosis. McMullen traveled, settling in several locations in Safety Harbor and surrounding areas. He would become a prolific contributor to the Pinellas Peninsula's growth.

Many followed, entrepreneurs and dreamers—hardworking, industrious people who strengthened the backbone of the young community.

A 1910 map shows that the center of town was located northeast of where Main Street is today, with Grand Central Avenue being the business center. There are scarce records of what was there, but it is known there was at least a general store and a post office. The main dock was north of its current location and provided access to Tampa by ferry. The business center moved to First Avenue (Philippe Parkway) and Main Street in the early 1900s.

Records in Tallahassee date Safety Harbor's incorporation to 1915. Due to the financial difficulties Safety Harbor was experiencing, when town leaders learned of a new countywide plan for road construction, they chose not to incorporate until such roads were built, thereby deferring the hefty cost to Pinellas County. In 1917, Safety Harbor was officially incorporated, and the rest, as they say, is history.

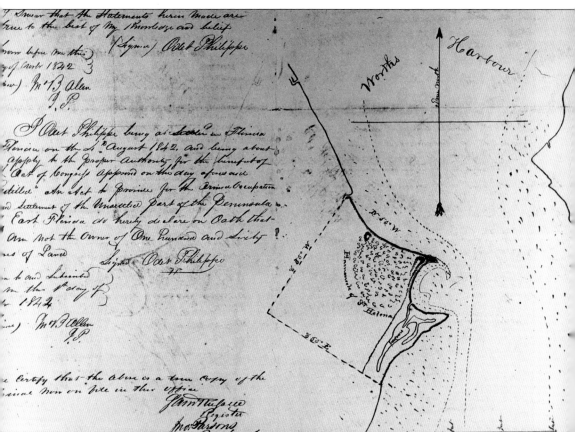

The Armed Occupation Act of 1842 offered each head of household 160 acres and one year's rations from the federal government. In return, claimants were required to settle and cultivate five acres or more for a period of five years and to provide militia service, if needed, against Seminole Indians and runaway slaves. The Second Seminole War had ceased, and the government needed to populate Florida to suppress future uprisings. The first non-native person known to have settled in what is now Safety Harbor was Odet Philippe. Supposedly, "Count" Philippe was born in Lyon, France, and was a childhood friend of Napoleon, later serving as his chief surgeon in the French navy. Philippe was also said to have befriended pirates; however, although many have tried, none of these tales have been substantiated. (Courtesy of Heritage Village Archives and Library.)

Odet Philippe's primary legacy is the introduction of grapefruit to Florida. He cultivated citrus groves and grew grapefruit from seeds, advancing a unique method of budding and grafting to enhance his crop. He was generous with his knowledge, which allowed others to succeed in further developing Florida's citrus industry. (Courtesy of Safety Harbor Public Library.)

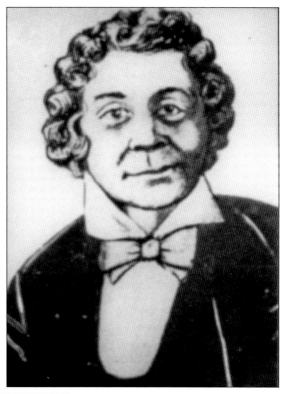

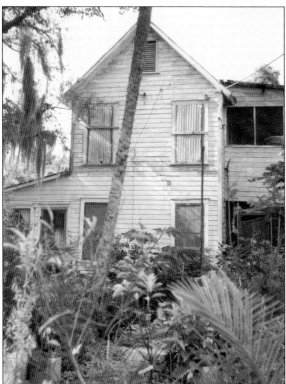

Odet Philippe named his homestead St. Helena after the island where Napoleon was exiled. In 1848, likely the most powerful hurricane ever to hit the region destroyed his main house. He, his family, and their slaves took refuge on the Tocobaga Indian mound. Philippe rebuilt and later constructed this house on his homestead as a wedding gift for Meliney, the youngest of his four daughters, who married Richard Booth. (Courtesy of Heritage Village Archives and Library.)

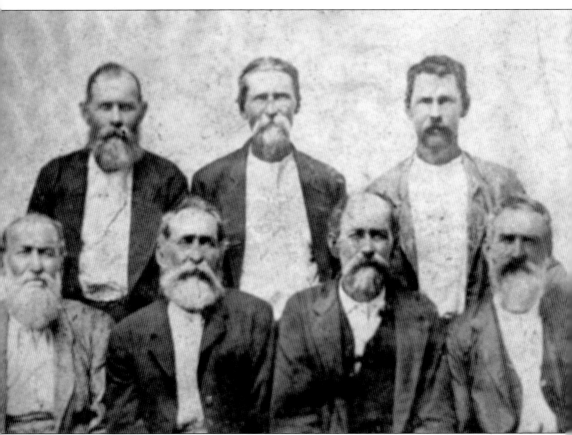

Pictured here are the McMullen brothers. From left to right are (first row) William, Thomas, James, and Daniel; (second row) John Fain, David, and Malcolm. They eventually all settled in Florida, but the migration began in 1841 with 18-year-old James, who had contracted tuberculosis. To recover and to keep his family safe, he left their home in Georgia and headed to Florida on horseback. James arrived across the bay at Rocky Point and then went to an area that became known as Bayview. Eventually, he made his way to Philippe Hammock where he encountered Odet Philippe and Richard Booth. On a trip back to Georgia, James stopped in Brooksville, Florida, and met Elizabeth Campbell. They married in 1844. In 1861, James helped form a company of volunteers from the Pinellas Peninsula and served as captain in the service of the State of Florida, based at Clearwater Harbor. (Courtesy of Safety Harbor Public Library.)

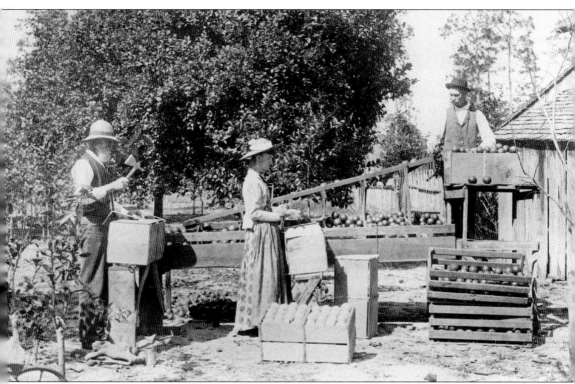

At the conclusion of the Civil War, James Parramore McMullen, "Captain Jim," established a farm, profiting from cattle and cotton. Eventually, he converted his farm and became one of the most successful citrus growers in the county. Needing a better way to transport fruit, he invented these wooden crates, which added to his productivity and wealth. He and his wife, Elizabeth, raised 11 children of their own and fostered 25 orphans. Elizabeth aided the community as a midwife, overseeing the births of approximately 55 children. The McMullen home not only served as a makeshift hospital, but also a welcoming stop for travelers. Elizabeth died in 1890 at the age of 65. James followed in 1895 at the age of 71. The people shown in this photograph are unidentified. (Courtesy of State Archives of Florida.)

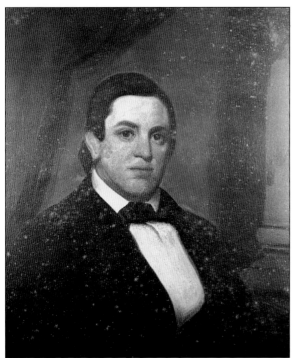

Col. William J. Bailey (1807–1872) served at Fort Brooke during the Second Seminole War. Allegedly, he and another officer had taken a Seminole man prisoner. This captive told him about healing waters that flowed at the west shore of Old Tampa Bay. Bailey purchased the springs from the US government in 1855. Bailey Springs waters were made available free of charge to the public. (Courtesy of State Archives of Florida.)

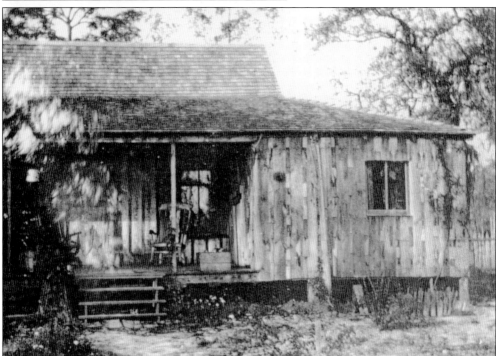

This early Safety Harbor log home had a breezeway or dogtrot down the middle with one or two rooms on each side. There was no front door and few windows. A covered porch served as a sitting area, and a kitchen was likely built outside. Its chimney was at the gabled end, and the home was raised instead of on a foundation. (Courtesy of Safety Harbor Museum and Cultural Center.)

Ortancier (Booth) Youngblood (1845–1925) was the oldest child of Richard Booth and Meliney Philippe. The home built for her mother by Odet Philippe, her grandfather, was later moved from Philippe Hammock to the northeast corner of North Bayshore and Grand Central Avenue. Ortancier and her husband, Seymour Youngblood, ran a general store and post office there in the late 1800s. Seymour was Safety Harbor's first postmaster. (Courtesy of Safety Harbor Museum and Cultural Center.)

Ortancier and Seymour Youngblood had seven children. Their youngest, Robert E. Lee Youngblood (1868–1953), was named for the Confederate general. Seymour often repeated the story of how he had been ill during the war. When he returned from the hospital to active duty, General Lee witnessed his frail condition and invited Seymour to ride on the back of his horse. (Courtesy of Safety Harbor Museum and Cultural Center.)

Bernard and Rebecca Lohmeyer were among Safety Harbor's post–Civil War pioneers, arriving in 1883. They settled on a 200-acre homestead that later became the subdivisions of Crestwood Oaks, Fernbrook, and the area that includes the community center on Ninth Avenue. After Bernard's death in 1908, Rebecca sold some of the land and then donated some to the city, which allowed the railroad a throughway. (Courtesy of Safety Harbor Museum and Cultural Center.)

Carl Lohmeyer (1890–1971) was the son of Bernard and Rebecca Lohmeyer. Between 1911 and 1915, he and his cousin Stephen Talmadge erected and managed an electric plant that provided lighting to local homes each evening from 6:30 to about 11:00. He was also able to provide electric lights on Main Street for a time and did so as a community service. (Courtesy of Safety Harbor Museum and Cultural Center.)

Virginia Hernandez (Bailey) Tucker (1844–1931) was the daughter of Elizabeth Ann (Williams) Bellamy Bailey and Col. William J. Bailey, the first developer and promoter of the springs. Virginia was raised on a large plantation in Lyndhurst, Florida. In 1864, she married Capt. James Felix Tucker (1840–1913), a Confederate veteran of the Civil War. After inheriting the springs from her father, Virginia and James developed and further advertised them, which brought consistent tourism to the town. After James died, Virginia managed the springs for several years along with her son-in-law W.E. Sinclair before eventually selling her interest in the property. James and Virginia Tucker are interred at the Holy Spirit Episcopal Church cemetery in Safety Harbor, on their original property. (Both, courtesy of State Archives of Florida.)

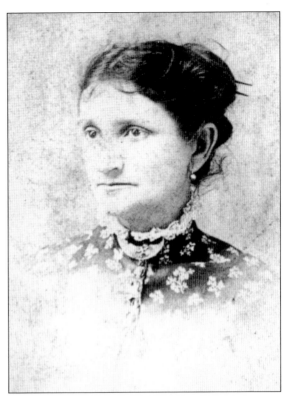

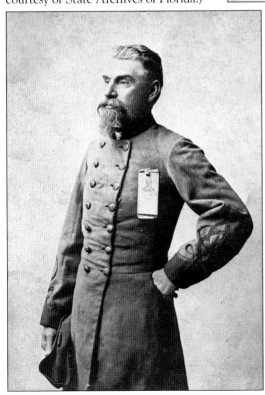

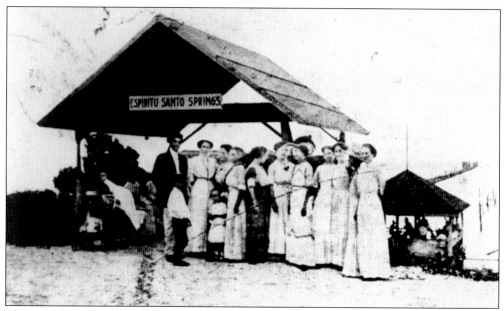

The story that Hernando de Soto landed at Safety Harbor and named the springs has remained a vibrant part of local lore for at least a century. The Baileys' promotional pamphlet printed in 1910 proclaimed that the Espiritu Santo Springs were "The Original Fountain of Perpetual Youth sought for by Ponce de León, and discovered by Hernando De Soto in May, 1539." People flocked from far away to experience the healing waters, and their health may likely have improved due to the high-quality makeup of the springs' mineral contents. But there were unbelievable claims, too. Perhaps due to a testimonial by J.C. Green, in which he stated the waters healed him of paralysis, the town became known as Green Springs in the latter part of the 1800s and early 1900s. For a time, it was also known as Espiritu Santo Springs, thanks to the springs' promoters. (Both, courtesy of Safety Harbor Public Library.)

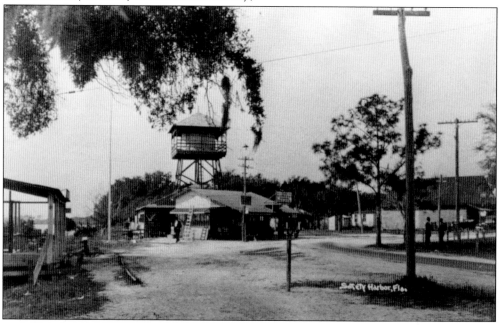

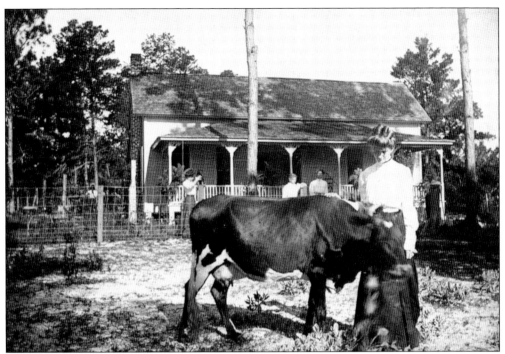

Virginia and James Tucker had six children: Eliza, Pelham, Eugenia, Virginia, Rosalie, and Susan, who is shown standing in front of her family's home next to her cow. In the background are, from left to right, Rosalie, Virginia, Eugenia Livingston, and Virginia's brother Burton Bellamy Bailey. This home was near the Tucker mansion property. (Courtesy of Safety Harbor Public Library.)

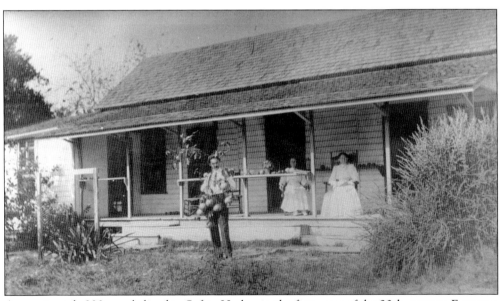

Approximately 200 people lived in Safety Harbor in the first years of the 20th century. Everyone knew each other, and the community helped one another by trading in areas of personal abundance, such as meat, fish, and produce. Each family had a garden, and most grew citrus. (Courtesy of Heritage Village Archives and Library.)

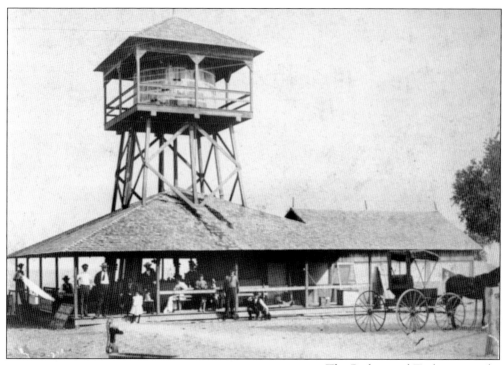

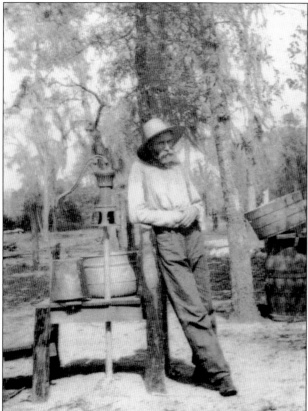

The Baileys and Tuckers owned the springs for approximately a half century. Visitors gathered near the shoreline at the pavilion to drink the waters, which, depending on the spring it came from, were said to taste sulfuric, salty, or "pure." Dances and parties were hosted there, and guests could stop for a while and cool down. (Courtesy of Safety Harbor Public Library.)

Spring waters were available to residents, and freshwater wells were located throughout town. Many homes had running water in the first years of the 20th century, but there were also those who pumped their own from community wells. Pictured here is Iver Seals (1856–1935), a citrus grower, extensive property owner, and Carl Lohmeyer's father-in-law. (Courtesy of Safety Harbor Museum and Cultural Center.)

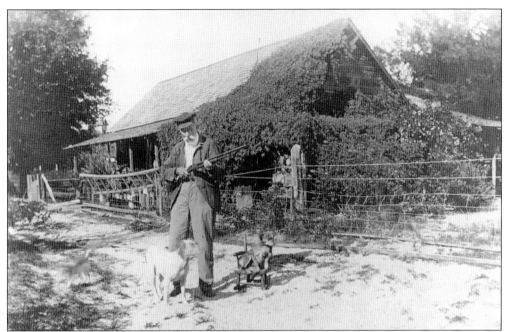

Hunting and fishing were necessary, as was cultivating the limited types of fruits and vegetables that would grow in sandy soil. Fleas and mosquitos tormented both humans and animals. Furniture and clothing were handmade, and Spanish moss became mattress stuffing. In many homes, one pair of shoes would be worn for years, or until they fell apart. Pictured here is Iver Seals, a Main Street resident and citrus grower. (Courtesy of Heritage Village Archives and Library.)

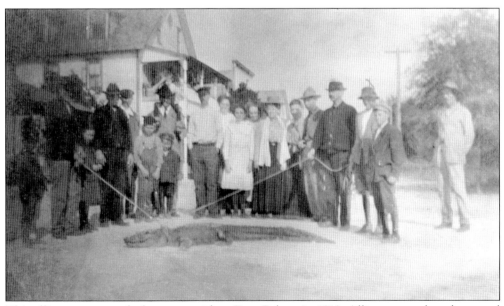

This alligator was caught by town resident Dan Cahow in 1910. Alligators, rattlesnakes, coral snakes, panthers, bears, and the ever-present wild boar that rooted up gardens and premises were not uncommon. Alligators were seen more often in Safety Harbor than they are today, most likely due to easy access to lush, swampy areas. (Courtesy of Betty Joe McMullen.)

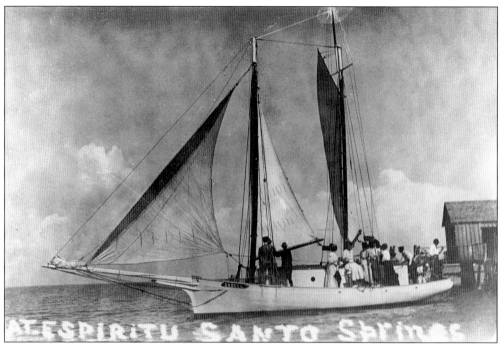

The *Sadell*, owned and sailed by Captain Bishop, traveled between Tampa and Safety Harbor on fishing excursions and was the setting for "yachting parties" along the trout banks and grouper banks in Tampa Bay. On one such excursion in July 1914, it was reported that 150 fish of many varieties were caught by the boat's passengers. (Courtesy of Heritage Village Archives and Library.)

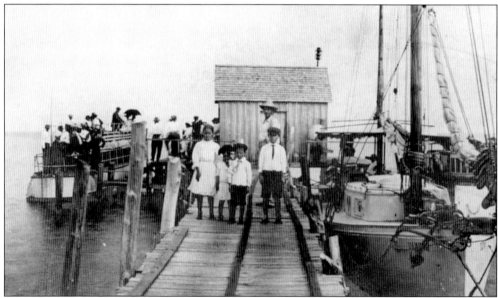

Ferries departed the canal at Port Tampa for excursions to Espiritu Santo Springs, including the *Juanita*, *Mistletoe*, *Penobscot*, and the *Ada May*. The ferries each accommodated 25 to 30 passengers. Round-trip fare cost 50¢. J.H. May, commander of the lines, owned Philippe Hammock from 1901 to 1906. (Courtesy of Heritage Village Archives and Library.)

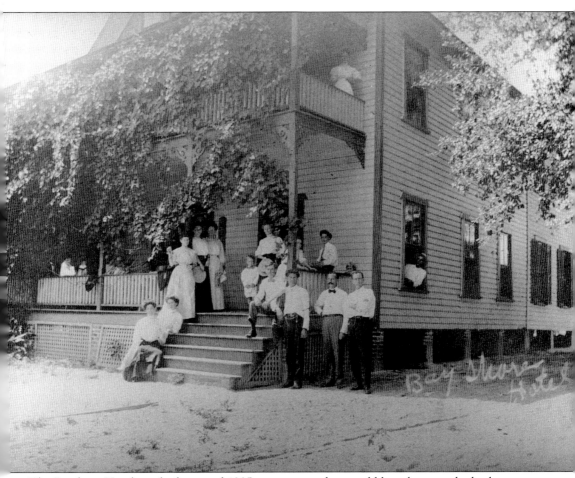

The Bayshore Hotel was built around 1905 on property that would later become the back grass area of the Safety Harbor Museum and Cultural Center at 329 Bayshore Boulevard. The hotel was owned by R.T. Youngblood and had 42 rooms. On September 17, 1908, at 2:30 a.m., engineer James Black of the ferry *Penobscot* awoke to the smell of smoke. He dressed quickly and ran from door to door, pounding his fists and yelling a warning to all 27 guests. No one was hurt; however, most lost everything but what they were wearing. The fire was determined to have started from a kerosene lamp in the bathroom on the second floor. The hotel had the capacity to accommodate 140 guests at one time. The hotel and the fire were forgotten until an archaeological dig in 1987 when charred remains were discovered by University of South Florida archaeology students. (Courtesy of Heritage Village Archives and Library.)

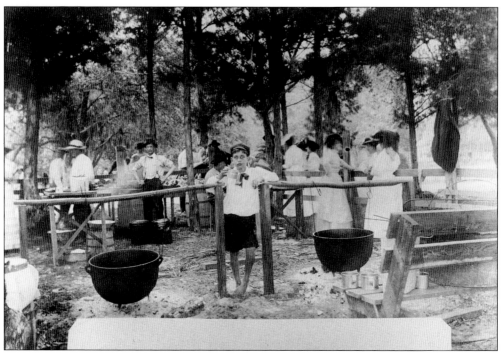

Fish fries brought out the entire community for plenty of fresh fish, watermelon, squash, sweet potatoes, pies, and more. Music, singing, games, and races took up most of the day, and in the evening, dances at the pavilion went on into the night. The above event occurred on May 1, 1909, a May Day celebration at Lovers' Oak. The event below was in Pioneer Park, now the grounds of the Safety Harbor Resort and Spa. (Both, courtesy of Heritage Village Archives and Library.)

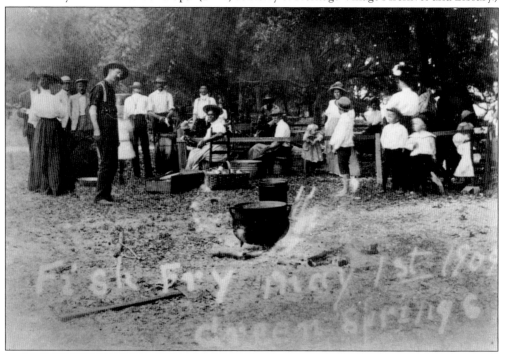

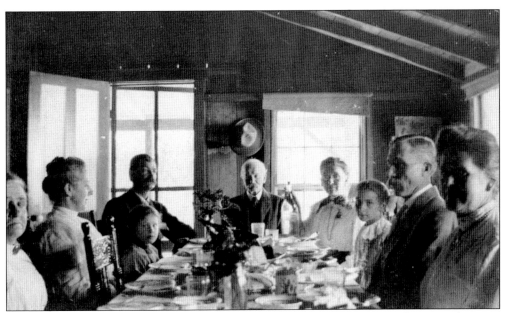

The log cabin at 600 Third Street South was owned by several families before this 1910 Christmas dinner at the Cahow residence. Above, Dan Cahow sits at the head of the table. Next to him, his wife, Nellie, rests her hand on a jug of spring water. The others are unidentified. According to *Grandmother Snedecor's Story* by Emily Snedecor, the home was built by her father, James George Snedecor, in 1881. However, some believe it was built earlier due to a fireplace brick dated 1876. Under the house is another brick dated 1865. William F. Leech built Ingleside at 333 South Bayshore Boulevard around the time he purchased the cabin from the Snedecors. His land between houses became contiguous. (Above, courtesy of Betty Joe McMullen; below, courtesy of Safety Harbor Museum and Cultural Center.)

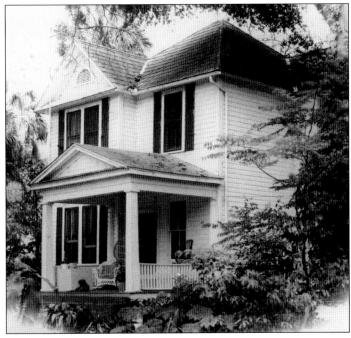

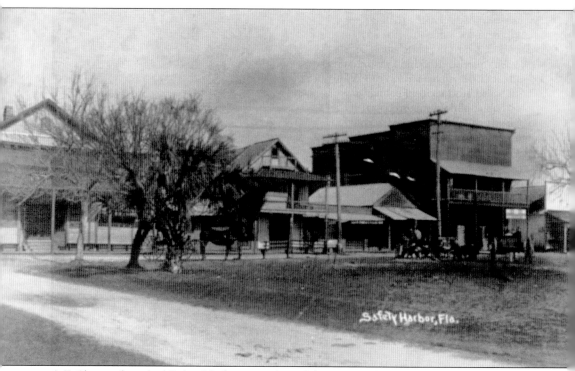

A.E. Shower described Safety Harbor to readers of the *St. Petersburg Times* in December 1915. He listed the businesses, which included six stores handling general merchandise and groceries, an electric light plant, a drugstore and cool drink stand, and an ice cream parlor. He mentioned a hardware store, a furniture store, a bank, a printing office, two pressing shops, a feed store, a shoe repairer, a meat market, and a newsstand. There were two barbershops, a garage, a notion store, a livery and feed store, hotels, rooming houses, and a restaurant. The town had a blacksmith shop, a newspaper, five churches, two fraternal organizations, and "two doctors to look after the ills of the human race." (Courtesy of Charles Russell III.)

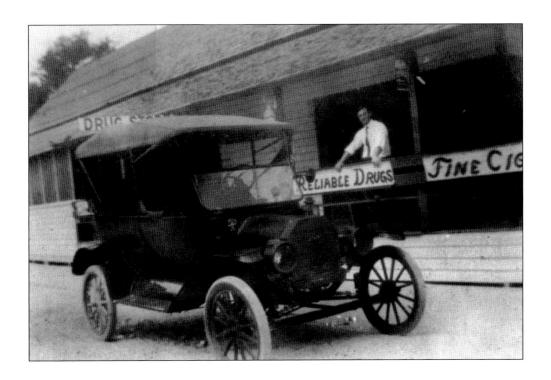

David Barron opened a drugstore on the northwest corner of First Avenue and Main Street in 1914. He had come to Green Springs from Virginia, where he had been a pharmacy clerk. Soon, the town would nickname him "Doc" Barron. (Above, courtesy of Marilyn Kirkpatrick Halsey; below, courtesy of Charles Russell III.)

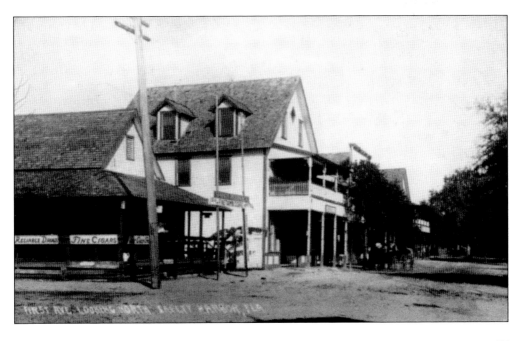

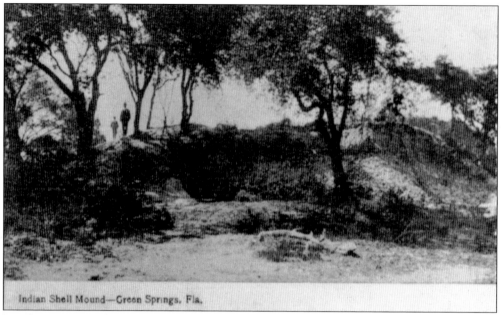

Indian Shell Mound—Green Springs, Fla.

In 1894, a *Tampa Tribune* article described an outing hosted by W.F. Leech at the log cabin. Guests visited a shell mound that measured 25 yards long, 10 yards wide, and 15 feet high. In 1906, the Historic Epicurean Shell Mound Club visited the Tocobaga mound, which still exists in Philippe Park. Beginning around 1910, several mounds throughout the area were destroyed. Their ancient, accumulated shells were used for roads. (Courtesy of Safety Harbor Public Library.)

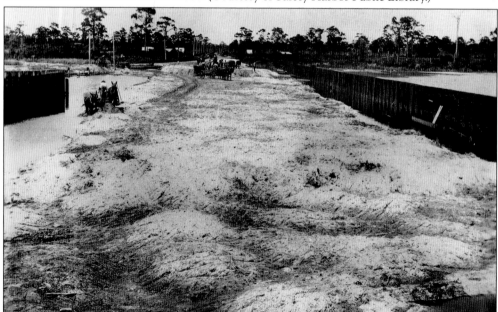

In the 1880s, local residents, organized by the McMullen and Booth families, cleared the area's first oxcart trail. The only access from Tampa to Safety Harbor was a sandy trail through Oldsmar. Traveling to Clearwater or St. Petersburg meant traversing the same trail. In Safety Harbor, roads and bridges such as this one were built in stages, from sand to shells and later bricks. (Courtesy of Heritage Village Archives and Library.)

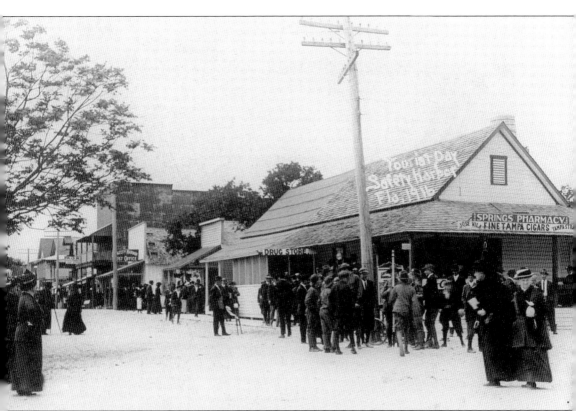

The precursor to the chamber of commerce, the county's Board of Trade, comprised of many Safety Harbor residents, organized a day for visitors to enjoy the beauty of the little town on the bay. On March 9, 1916, approximately 400 people arrived from Tampa and surrounding areas for a highly successful tourist day. Town leaders organized games, a picnic, entertainment, and tours. (Courtesy of Safety Harbor Museum and Cultural Center.)

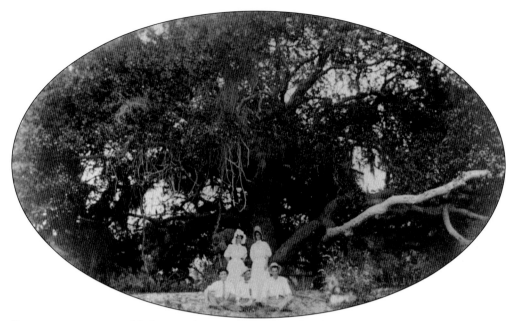

For every generation of Safety Harbor residents, there has been at least one special landmark tree. The Lovers' Oak, with its far-reaching limbs and canopy of shade, was that tree from the 1890s to at least the 1940s. The tree still exists north of the museum on Bayshore Drive, but many branches were cut decades ago to accommodate an apartment complex. (Courtesy of Safety Harbor Public Library.)

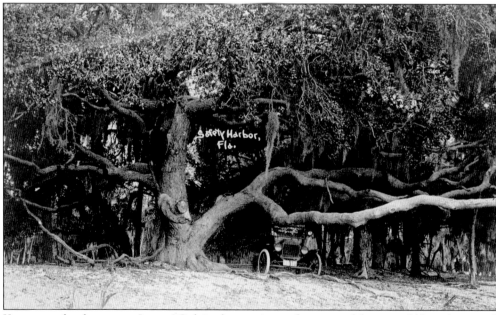

Young people often met at Lovers' Oak in the evenings, where one of them would have borrowed their mother's wash pot to slow cook chicken "pilleau." The pot was placed on coals in a hole in the sand. Chicken, salt, and pepper were cooked for hours, and rice was added later. Banjos, harmonicas, and other instruments accompanied singers around a fire. Sweethearts danced and carved their initials into branches. (Courtesy of Safety Harbor Public Library.)

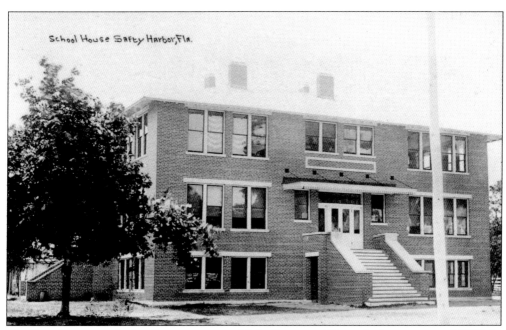

The first documented schoolhouse was near Main Street and Seventh Avenue around 1907. In 1916, a three-story building was constructed at the elementary school's current location. A 500-seat auditorium, which still exists, was built in 1926. Additions were added in 1936 for grades one through nine. In 1961, the original building was razed, and the 1926 additions were remodeled. The junior high relocated in 1963, and in the mid-1960s, integration opened the schools to all children. (Courtesy of Safety Harbor Public Library.)

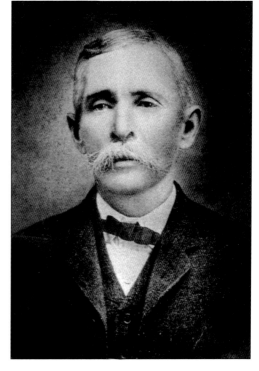

George Washington Campbell (1854–1925) served as Safety Harbor's first mayor from 1917 to 1919. Beginning in 1868, he and his wife, Annie (Nelson), lived between Clearwater and Safety Harbor. This community leader successfully ranked among top citrus growers on the west coast of the state. In 1913, it was reported that he picked 1,000 boxes of grapefruit from a single acre. (Courtesy of Safety Harbor Museum and Cultural Center.)

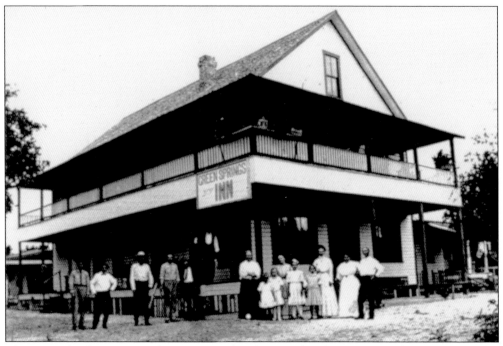

Close to midnight on September 1, 1917, only a few months after Safety Harbor incorporated, a fire started at the Green Springs Inn, which was located where the library stands today. Gunshots signaled downtown residents. Every able-bodied person rushed outside and immediately began helping. Some formed a bucket brigade to douse the flames. Other neighbors helped to remove belongings from homes and businesses, but in the end, the inn quickly burned and all buildings in the first block of Main Street were destroyed—all but the structure now housing the chamber of commerce at 200 Main Street. (Both, courtesy of Safety Harbor Public Library.)

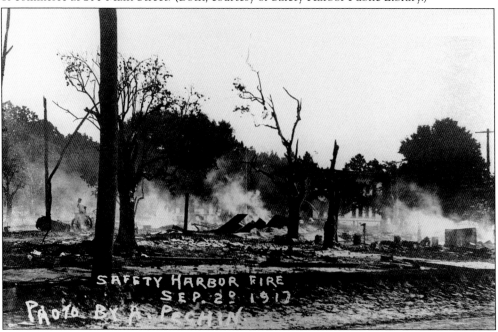

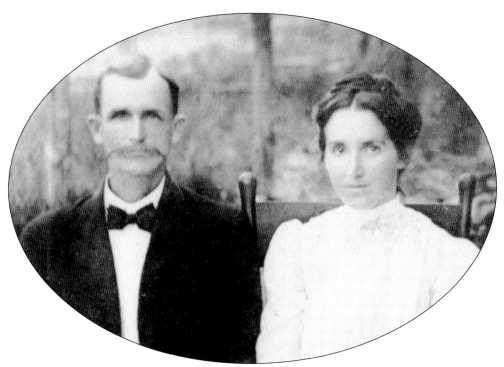

J.D. McElveen and his wife, Helen Irene (Campbell), daughter of the city's first mayor, G.W. Campbell, had three children when J.D. built the Hotel Frances at 454 Main Street. They named it for their oldest daughter. Originally, a wooden walkway led to a separate building with a kitchen and washroom. The family of five moved into the hotel in 1914, and the couple went on to have two more children, including Paul, who served as both commissioner and mayor (1952–1956) like his grandfather. The building changed hands over the years, becoming a new hotel, boardinghouse, apartments, a restaurant, and retail shops. (Above, courtesy of Safety Harbor Museum and Cultural Center; below, courtesy of Betty Joe McMullen.)

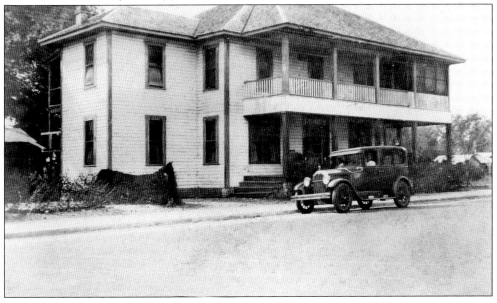

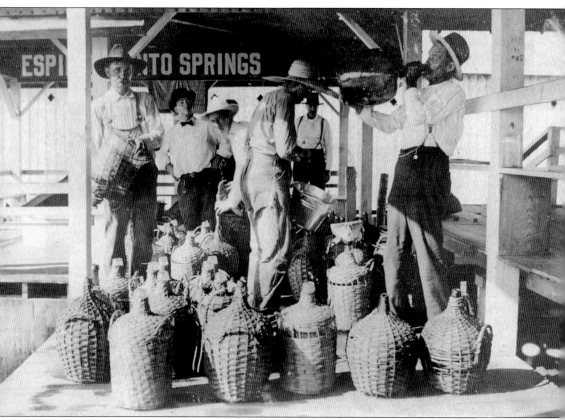

People came from all areas of Florida and out of state to experience the springs' healthful benefits and alleged cures. The water was shipped in five-gallon glass jugs to as far away as Europe. The five springs included Beauty Springs, Stomach Springs, Kidney Springs, Liver Springs, and Pure Water Springs, so free of sediment it was used for ships' batteries. (Courtesy of Betty Joe McMullen.)

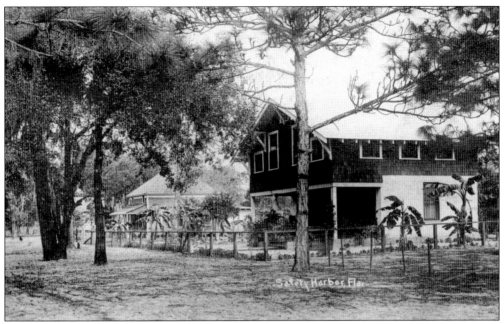

This postcard to a friend in Kentucky, postmarked February 28, 1920, details the visitor's stay at this lodging house in Safety Harbor. Room and board totaled $12 a week. The water, which the writer greatly enjoyed, cost 5¢ for as much as a patron could drink. (Author's collection.)

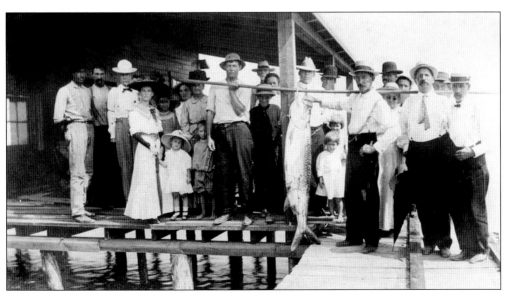

The dock at Espiritu Santo Springs functioned as a point of entry and departure for boaters on fishing excursions. The clean waters of Tampa Bay provided ample varieties of fish, including trout, tarpon, mullet, redfish, and grouper, as well as shrimp, crabs, and oysters. (Courtesy of Betty Joe McMullen.)

The Tampa & Gulf Coast Railway arrived in 1914. Locals finally had a fast and reliable resource for travel and to receive and deliver mail. In 1917, the line merged with the Seaboard Air Line Railway, and both passenger and cargo trains frequented the town daily. The depot was south of Main Street at Ninth Avenue. Passenger service ended in 1963, and the station was demolished in 1965. (Courtesy of Betty Joe McMullen.)

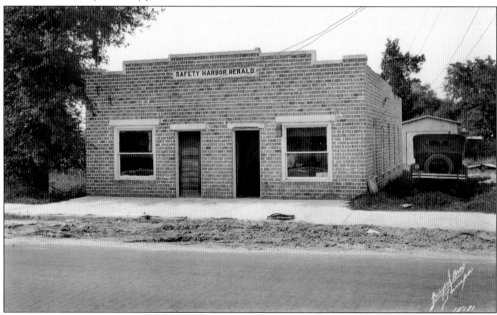

Alva Ernest "A.E." Shower began publishing the four-page *Safety Harbor Herald* in June 1916 in a shack in the northwest corner of what is now John Wilson Park. Over time, the weekly paper grew to 12 and then 16 pages. The *Safety Harbor Herald* moved to this location at 509 Main Street in 1920. Shower retired in 1957. His family continued to operate the paper until 1976. (Courtesy of Safety Harbor Public Library.)

In 1920, Safety Harbor's population was 429, having doubled in the first two decades of the 20th century. Most folks were not rich, but if a family owned at least one cow, one horse, a few chickens, and a hog, they were wealthy enough. Children swam in the bay and spent all day outside, barefooted. Livestock roamed the town's dense wildernesses, and roosters woke the city at sunrise. Sometimes the train to Tampa had to stop for a pig named Princess, who seemed to know just the right time to cross the tracks. (Both, courtesy of Safety Harbor Public Library.)

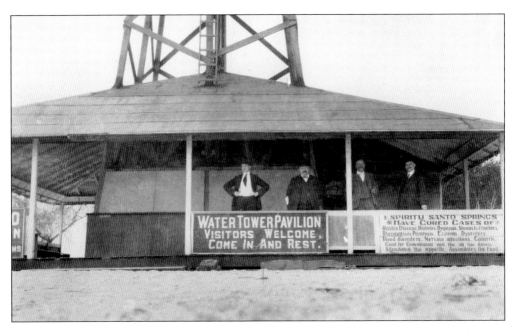

Tourists continued arriving to sit under several different covered shelters and drink the "healing waters." Sand was pumped inside the seawall for the Espiritu Santo Springs Company, filling approximately 600 feet into the bay. The company had major plans for Safety Harbor's waterfront. Designs for a massive hotel and a pier that automobiles could drive on fell through, but the new, open land would continue to attract builders. (Both, courtesy of Heritage Village Archives and Library.)

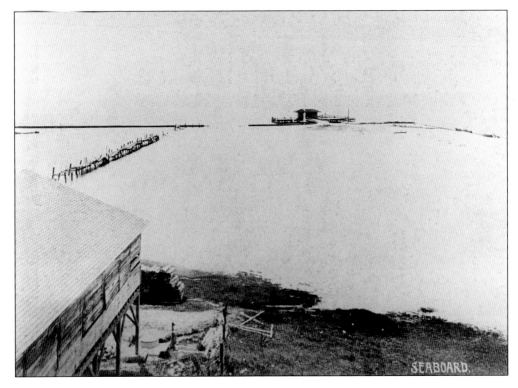

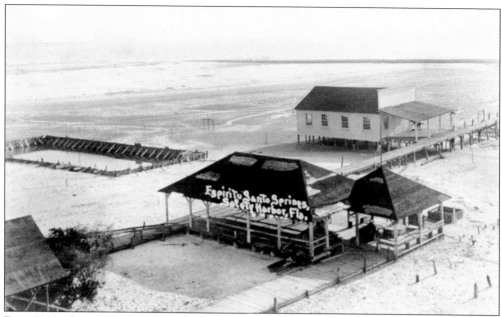

From 1916, when this postcard was mailed, to 1921, when these buildings and pool were destroyed, the Espiritu Santo Springs Company was in the process of improving its investment. At the forefront is the pavilion, where visitors rested and enjoyed the spring water. To the left is the swimming pool, which would naturally fill from the ever-flowing mineral springs. The bottling house is at right. (Author's collection.)

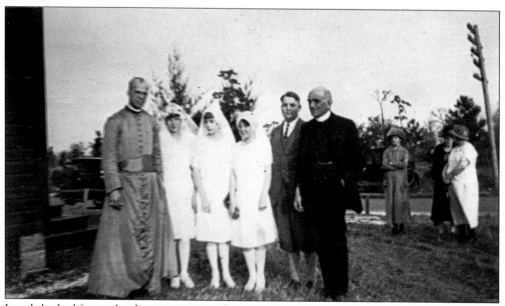

Locals looked forward to hosting visiting clergy members for annual evangelical tent gatherings. Excitement escalated over approximately three weeks. Church memberships were a steady and important part of most residents' lives, which included not only a day of worship, but also many social activities such as picnics and occasional performances. (Courtesy of State Archives of Florida.)

John Whitledge was proprietor of the Green Springs Inn before it burned down in 1917. Around 1920, advertisements noted the "Whitledge Apartments" on the northwest corner of Fifth Avenue and Main Street with eight apartments for long- or short-term rental. It was sold in 1945 and became the Bowen Apartments. Theresa Bachus bought the building in 1949 and opened the Theresa Apartments. She and her husband rented rooms to jockeys during Oldsmar's horse racing season. They built a café next door, which later became an antique store and is now a cheesecake restaurant. In the 1960s, the Waverly Apartments took ownership, and for a time housed children with special needs. Later, the building was known as the Cattanach Apartments, and in the 1980s, it became office space. It was a retail shop with upstairs rental space for artists in the 1990s. The building was empty for many years but was finally refurbished by the Runnels family in 2020 as a location for their coffee shop, Café Vino Tinto. (Courtesy of Safety Harbor Museum and Cultural Center.)

Two

Land Boom to Great Depression

That is powerful moonshine they make over about Safety Harbor. Word is a bottle dropped in Mullet Creek caused a catfish to jump in a boat and attack a fisherman.

—Clearwater Evening Sun, 1921

On October 25, 1921, a hurricane rampaged through Pinellas County and much of Florida. The bridge between Safety Harbor and Oldsmar turned to rubble, and the road that would later become Bayshore Boulevard was ruined, covered in water and sludge. The winds ripped off the school's roof, and the Green Springs citrus packinghouse was demolished. Safety Harbor's lumberyard, located in Philippe Hammock, disappeared, turned into random piles of wood. Massive oaks were uprooted, and perhaps the worst part in the long term was the prolonged, devastating effect on the livelihoods of local citrus farmers.

The hurricane forced rebuilding, and the Espiritu Santo Springs Company immediately began by constructing a modern pavilion. Safety Harbor offered a unique setting for the flocks of new developers and buyers because there was an abundance of land available. Property changed hands, sometimes several times a year, at outrageous profits. In many cases, buyers only purchased lots to quickly resell.

Virginia Tucker, daughter of Col. William Bailey, the first owner and developer of the springs, built a Colonial Revival mansion just north of the springs. She also built the St. James Hotel. A developer named George Washburn constructed buildings on First Avenue and Main Street, including the Washburn Apartments, known as the Silver Dome building as well as the Alden Apartments, which included a theater on the first level. While some of the original buildings remain today, many were demolished decades later due to poor construction.

The city's debt grew as the Florida land boom ended. Homes were abandoned, many foreclosed upon, and those who remained were deeply affected by the country's financial crisis. Retrospectively, the 1920s and 1930s were historically important for the young city's evolution because the times forced a maturing of the small municipality.

Many areas that are now within Clearwater's boundaries were then in unincorporated Pinellas County, and for many decades, everywhere north of Gulf to Bay Boulevard and east of US 19 was considered Safety Harbor.

Bayshore Boulevard was one of the only roads paved with bricks in the first few years after the city's incorporation. Surrounding cities mocked Safety Harbor for the condition of the few roads they had. The city struggled financially, but soon the whole Gulf Coast would need financial assistance to repair infrastructure. (Courtesy of Safety Harbor Public Library.)

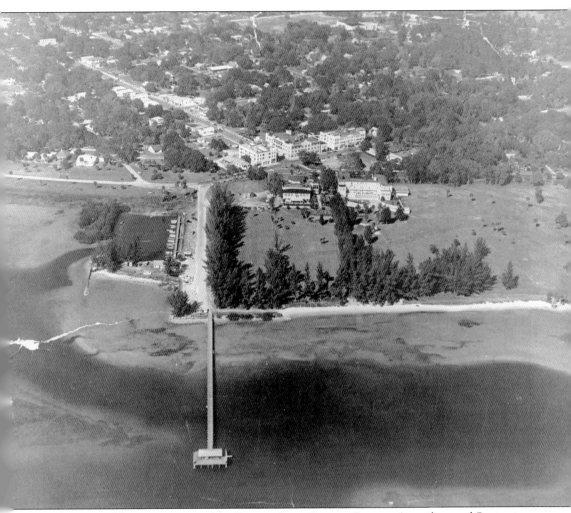

Early stages of the construction of the Espiritu Santo Springs Company's pavilion and Sanitarium after fill was added are evident in this 1924 aerial photograph. Several important buildings would be constructed to the west of this over the next two years, and more fill would be added to accommodate the growth. (Courtesy of Safety Harbor Public Library.)

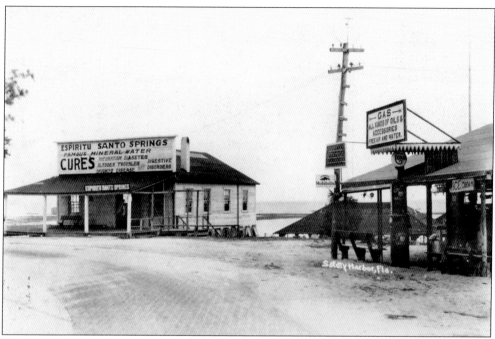

The Espiritu Santo Springs pavilion became a pile of splinters when the Tampa Bay Hurricane of 1921 hit Safety Harbor on October 25. The Espiritu Santo Springs water sales office moved 75 feet from its original location due to a 10- to 12-foot storm surge. The hurricane devastated Safety Harbor's already rutted, uneven roads. The pier and dance pavilion at its end floated into the bay, landing at the shore, where it knocked into houses. Centuries-old massive oaks were uprooted. Maximum sustained winds at landfall are estimated to have been 115 miles per hour. (Both, courtesy of Safety Harbor Public Library.)

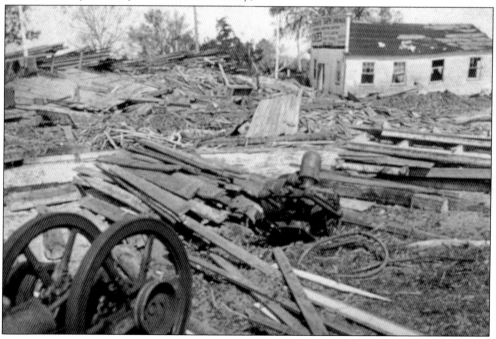

The Safety Harbor School, built in 1916, lost its roof and suffered damages from the hurricane. Temporary elementary school locations were set up in the churches, and junior high school students were bused to Clearwater by David Pipkin, whose automobile had been purchased for the commute. It took several months for repairs to be made. Older students returned to school in Safety Harbor in December 1922. (Courtesy of Safety Harbor Public Library.)

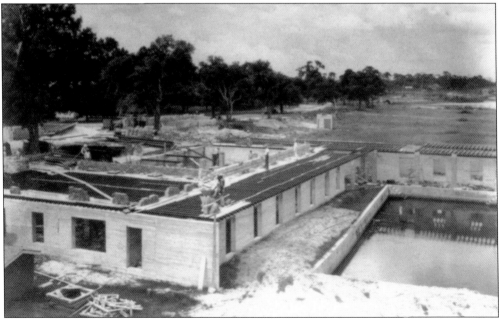

The Espiritu Santo Springs Company began building a sanitarium in 1923–1924. This view looking north shows the Pipkin Mineral Wells Hotel through the trees to the left. Safety Harbor was beginning to experience the Florida boom years, when developers spent in excess, believing real estate would only continue to flourish. (Courtesy of Safety Harbor Public Library.)

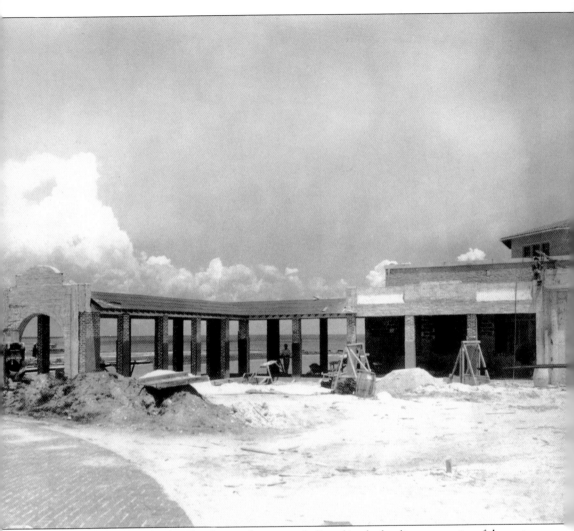

Likely everyone involved in developing the springs believed in the healing properties of the waters, but they also made business decisions that would continue to meet the growth of their clientele. The Espiritu Santo Springs Company completed construction of the pavilion and sanitarium in 1924, just prior to the Safety Harbor real estate frenzy during the Florida land boom. Once serving

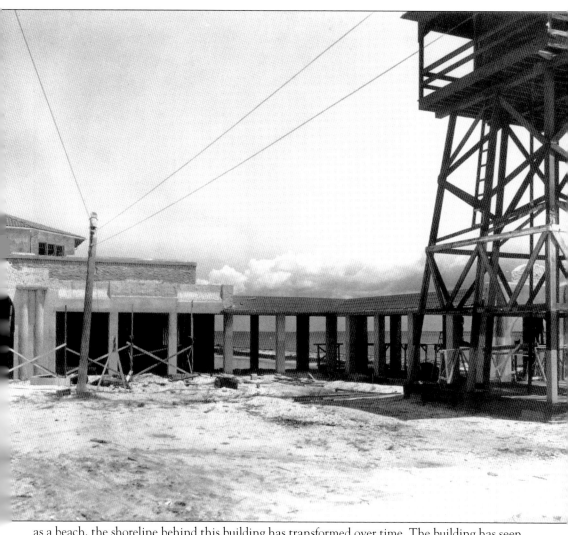

as a beach, the shoreline behind this building has transformed over time. The building has seen many owners come and go, and more construction over the next 100 years has added layers of history to this iconic structure's story. (Courtesy of Safety Harbor Public Library.)

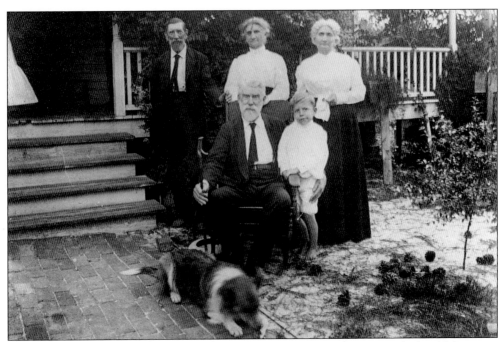

On August 11, 1919, the *Tampa Tribune* reported that Virginia Tucker acquired "the old drugstore property, long owned by George Booth" on the north corner of Main Street and First Avenue. It was thought she would sell the property, but instead, to the delight of the city, she built the St. James Hotel, naming it for her husband, who had died six years earlier at the age of 72. It had an elevator, a phone in every room, hot and cold running water, private baths, and electric lights. These were uncommon amenities for a hotel in a small city. While it is no longer used as a hotel, the building still exists today, and retail shops occupy its first level. Pictured above are, from left to right, (first row) James Tucker and his grandson E.S. McKenzie; (second row) Virginia's brother Burton Bellamy Bailey, Virginia Tucker, and Virginia's sister Christine Mays. (Above, courtesy of Heritage Village Archives and Library; below, courtesy of Safety Harbor Public Library.)

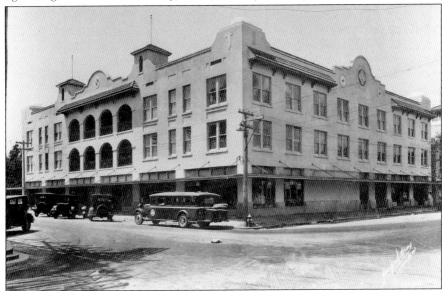

Virginia Tucker built this Colonial-style mansion around the same time as the St. James Hotel. She modeled Virginia Manor after the Bailey family's long-standing plantation home in Lyndhurst, Florida. The mansion had a winding staircase and elegant brass chandeliers, a parlor with sliding doors, private bathrooms, and a breakfast room that seated 15. (Courtesy of Heritage Village Archives and Library.)

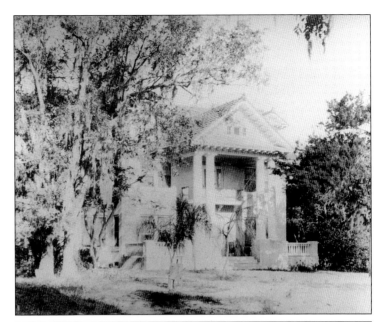

After decades as one of the city's most prolific developers, Virginia Tucker spent her retirement tending her roses, speaking with passersby, and sitting on her porch overlooking the bay—the same view in this photograph. Virginia Hernandez (Bailey) Tucker died in 1931 at the age of 87. (Courtesy of Heritage Village Archives and Library.)

In the 1920s and 1930s, Raymond Athy contributed to the construction of many homes and businesses throughout Safety Harbor, including his own house at 939 Suwanee Street, which later burned down. He had come to Safety Harbor to see George Woodell, and they immediately connected. Athy was elected to the city commission and helped build the St. James Hotel and the springs pavilion. He owned Safety Harbor Lumber on Ninth Avenue South, near the depot, which today would be on the south side of Main Street adjacent to the railroad tracks and near the American Legion parking lot. One side opened facing the bay and the other faced the railroad tracks for loading and unloading. (Both, courtesy of Danny Hill.)

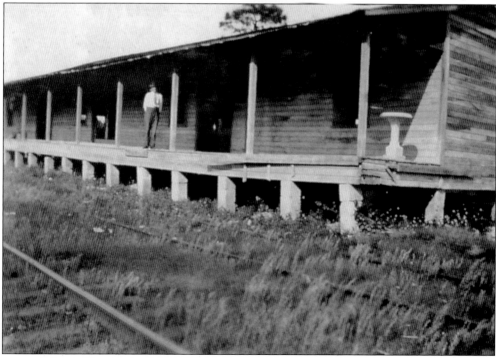

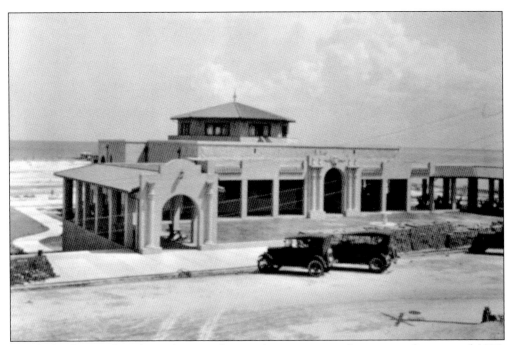

Word of Safety Harbor's love of camaraderie and entertainment began spreading around 1906. As popularity grew, several hotels and rental cottages opened, accommodating visitors from all over the country. Even more numerous were tent campers. In a 1920 *Tampa Tribune* article, the tents reached "at intervals all the way from Mullet Creek to a point well past the Lovers' Oak." The campers set up on a bluff—higher than the nearby shoreline, which remained "perfectly dry." Visitors spent their days bathing, fishing, and sitting under the pavilion enjoying the spring waters. (Both, courtesy of Safety Harbor Public Library.)

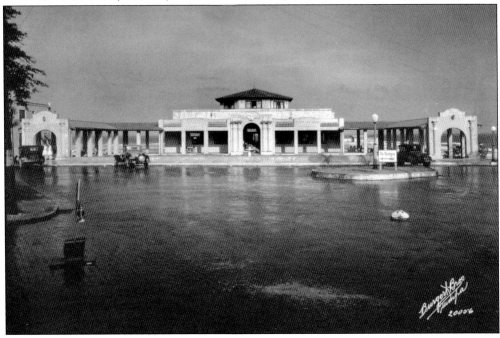

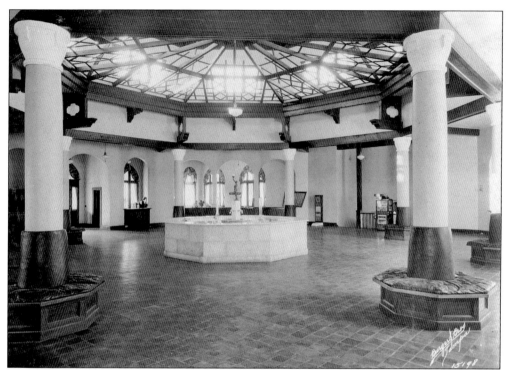

The Espiritu Santo Springs Company became so prosperous from those who came to bathe and "take the waters," that it continuously made improvements for guests. This view showcases the pavilion's 1925 interior, where visitors purchased water. (Courtesy of Safety Harbor Public Library.)

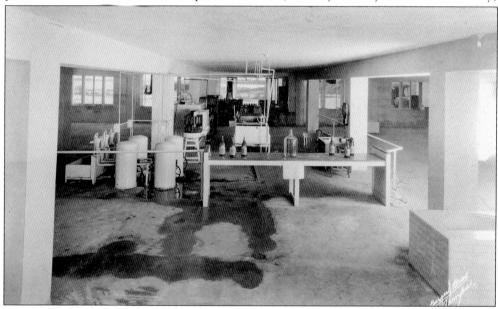

The company's water bottling operation, shown here in 1925, was under the pavilion. Several types of water were bottled here, each comprised of different mineral contents, supposedly curing many different ailments, from mood swings to kidney and liver diseases. (Courtesy of Safety Harbor Public Library.)

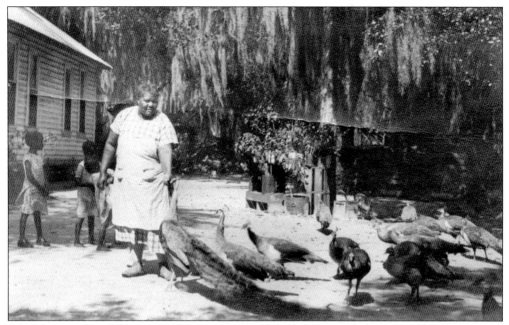

Ethel (pictured) and Eugene Williams were caretakers for the peacocks at one of the area's most visited tourist attractions. They lived in a cottage on Haines Road, now McMullen Booth Road. According to the *Miami News*, their home was "in the foreground of 19 pens of peafowl, located on a dirt road through a cluster of citrus trees" at Eugene Pearce's citrus groves. Ethel died in 1948 at age 47. (Courtesy of Heritage Village Archives and Library.)

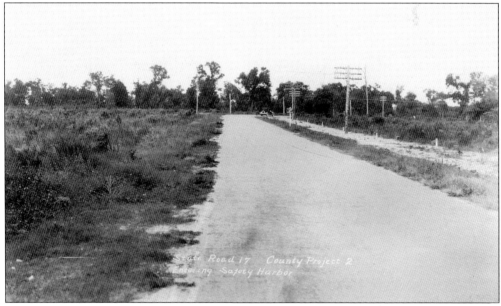

In 1914, State Road 590 was the first road to access Clearwater from Safety Harbor. It was not yet paved. Florida funded a roads program, which included State Road 17, County Project 2. Eventually, these roads connected Pinellas County to Polk County. Project 2 created State Road 590 from Coachman to Oldsmar by way of Safety Harbor. The section through Safety Harbor was completed in March 1925. (Courtesy of Heritage Village Archives and Library.)

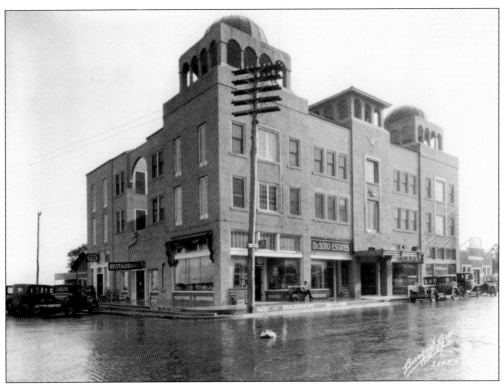

In 1925, during the Florida boom, a prolific developer named George Washburn erected two apartment buildings on properties along First Avenue and Main Street, with business space on the first floors. The Washburn Building, nicknamed the Silver Dome for the embellishments atop its roof, was at the southwest corner of what is now Bayshore Boulevard and Main Street. It was razed in 1981. In direct view, the Alden Apartment building along First Avenue, now Philippe Parkway and Second Street North, later became the location of the Safety Harbor Public Library. (Both, courtesy of Safety Harbor Public Library.)

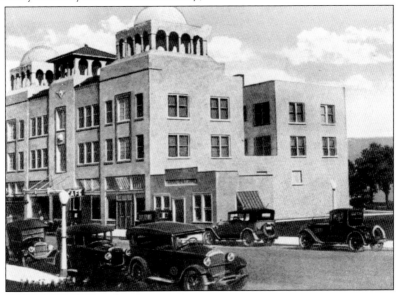

ALDEN THEATRE
SAFETY HARBOR, FLORIDA

FRIDAY—AUGUST 19, 1927

Douglas MacLean in "LET IT RAIN"—Screen Production

Also Comedy—"GOLF WIDOWS"

Three-Act Play by Local Talent

"THAT'S ONE ON BILL"
(Annual Play by Safety Harbor Epworth League)

CAST OF CHARACTERS

Uncle Jimmie—A Young Bachelor	Hilburn Blakley
Bill Haily—His Nephew	Guy McMullen
Battling Bennie Bozo—A Pugilist	Loraine Dwyer
Harry Dover—Engaged to Nell	Wilbur Pipkin
Ned Collins (Puffy)—Too Rich to Work	Bradley Pipkin
Patricia Niles (Patricia Pansy LaGloria)	Velma Pipkin
Lil—Her Friend	Ethel Brown
Mab Haily—Uncle's Choice for Bill	Elizabeth Smith
Mrs. Haily—Mother of Lil and Bill	Ella Adora Washington
Rosie—The Maid	Helen McMullen

Music furnished between acts by Mrs. H. Burch and daughter, Avery Lee.

Act I.—A Morning in July.
Act II.—A Week Later.
Act III.—Three Weeks Later.
Place—The Haily's Summer Home. Scene—The Garden.
Time—The Present.

THE STORY OF THE PLAY

Bill Haily objects to the efforts of his wealthy and youthful Uncle Jimmie to mate him with Mab, a sweet but quiet girl whom Uncle Jimmie has selected for a niece-in-law. The uncle has promised to leave part of his fortune to Bill if he will marry as instructed, and part of it to a prize-fighter, Battling Bennie Bozo, if Bennie remains unmarried.

Bill's sister, Lil, seeks to have her brother marry Mab as the uncle desires, and plots to make him tired of his romantic desire for a motion picture bride. So Lil gets her school friend, Patricia, to visit their home in the guise of a motion picture star, and Patricia loses little time in ensnaring the hearts of all the boys in the neighborhood. Bill so completely loses his head over her that he takes money from Uncle Jimmie's trunk to make an impression on the "movie queen."

The theft is discovered, and Mab, knowing who took the money, pleads guilty to save Bill. Patricia adroitly saves the situation, but by this time Bill is not so enamored with the dashing visitor, and remorsefully begins to appreciate Mab. It develops that while pretending to flirt with the others, Patricia has confessed her identity to Uncle Jimmie, and she brings a sudden end to her flirtations by announcing the marriage of the two, while the other romances are settled in equally satisfactory fashion.

Movies at the Alden Theater were so affordable, kids could get a seat and popcorn for a dime. The theater, usually only open on weekends, included a stage where local talent produced plays to entertain the community. In the 1940s, sometimes a local bluegrass band, the Harmony Boys, would entertain patrons before the weekly movie. (Courtesy of Betty Joe McMullen.)

Jennie Mock (1897–1986) lived with her husband, James, at 518 Second Street North, which is now the location of Marker 39's parking lot. What remains of their lives in Safety Harbor is a family tradition and the grand oak next to the restaurant. The oak was saved by James, an arborist who also worked for the city. Jennie raised chickens and started a family tradition that she passed on to their daughter Grace. (Courtesy of Gracine Reed and Aaron Stewart.)

Grace (Mock) Crawford (1921–1988) continued her mother's tradition. Every Sunday she would fry two chickens for supper while the house filled with family and guests. Grace's daughter Gracine also continued the tradition and passed it on to her own son Aaron Stewart, who took his great-grandmother's recipe and in 2012 opened a restaurant called Southern Fresh. (Courtesy of Gracine Reed and Aaron Stewart.)

Daniel M. Pipkin arrived in Safety Harbor in 1914 with his oldest son, Dave. Daniel Pipkin was a successful and prominent businessman in Polk County, but he became interested in the benefits of the spring water when he learned it could relieve his rheumatism. His wife, Sarah, joined him shortly thereafter. The couple (pictured) took a trip to Texas to experience the mineral waters there, and decided to return to Safety Harbor and establish a hotel. They took over the Espiritu Springs Hotel and named it the Pipkin Mineral Wells Hotel. Soon, he built a mineral steam bathhouse. Dave learned massage techniques and became known as "Dr." Pipkin. In 1920, the Pipkins moved their younger children to Safety Harbor and occupied the hotel. Daniel got involved in local government and was mayor between 1922 and 1924. The hotel was sold and renamed the Spa Park Inn prior to Daniel's death in 1930 at age 69. Sarah died in 1950, aged 84. (Right, courtesy of Betty Joe McMullen; below, courtesy of Heritage Village Archives and Library.)

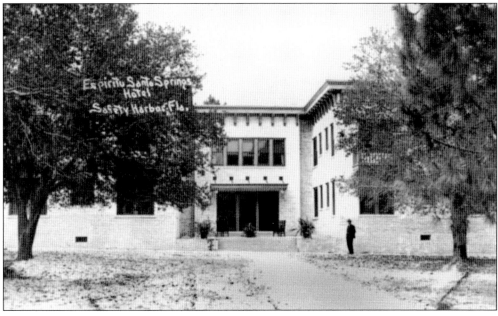

Joseph Lynn "Uncle Joe" Aunspaugh moved with his wife, Arrie, and their sons Louis and Paul from Clearwater to Safety Harbor in the summer of 1924 to open a bakery. In 1932, he was named justice of the peace in District Three, which included Safety Harbor. He died in 1936 at the age of 69. (Courtesy of Richard Aunspaugh.)

There is evidence of two bakeries in town at that time, or one bakery known as both the Safety Harbor Bakery and the Green and White Bakery. According to Joe Aunspaugh, Safety Harbor's bakery business was not a long-term success because "the kids ate all the profits." (Courtesy of Safety Harbor Museum and Cultural Center.)

Attention

Introductory Opening
of the
SAFETY HARBOR BAKERY
SATURDAY, JUNE 28

In appealing to the general public and good people of Safety Harbor and impressing on you the utmost necessity of an up-to-date Bakery with a full line of all things good to eat found in a bakery to be supported by our home trade, we beg to offer you the following goods subject to your approval and all patronage will be greatly appreciated and this will not be a one day proposition but a home institution, small but growing. As an inducement for you to visit our store on Main street, next to the bank, we will offer a

LARGE CAKE FREE

to the one holding the lucky number drawn on Saturday night at 8 o'clock. Save the coupon below and present name and number any time before 8 p. m. Sat., June 28th

All kinds of Pies Doughnuts French Pastries Coffee Cakes
Jelly Rolls Devil's Food Wine Cakes
Cocoanut Squares Layer Cakes Small Cakes Cream Rolls
And Everything Found in a Good Bakery

DON'T FORGET OUR HOT ROLLS AND BREAD EVERY DAY AT 5:30

Name
No. 1035

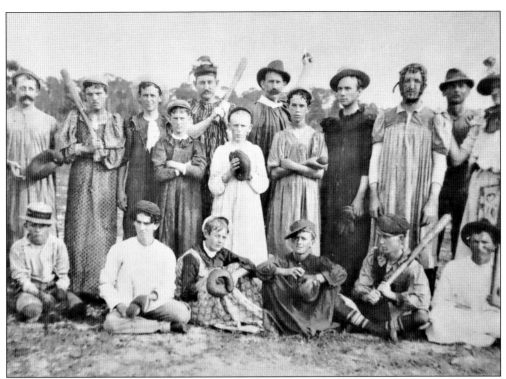

Many of Safety Harbor's young men played baseball at a diamond downtown, behind the spa, near where today's Waterfront Park is located. The game was not only a fun pastime, but it also provided entertainment for the community. Joe Aunspaugh, standing at left, and his brother Mark, in the rear center with his left hand raised, are shown with teammates in dresses. The back reads, "clowning around." (Courtesy of Richard Aunspaugh.)

These 1927 McMullen men were all masons. Most of Safety Harbor's men and many women participated in at least one club or fraternal organization, including the Women's Civic Club, Kiwanis, Eastern Star, Royal Neighbors, Modern Woodmen of America, Woodmen of the World, and Freemasons. A lodge specifically organized in the black community to assist in the details of burial was the St. Paul Helping Hand Society. (Courtesy of Betty Joe McMullen.)

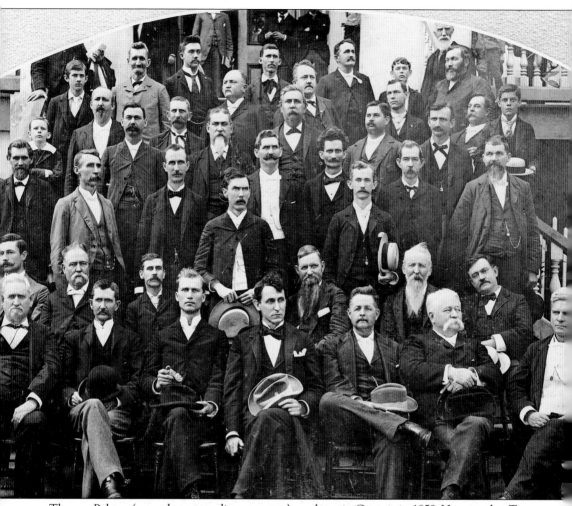

Thomas Palmer (second row, standing at center) was born in Georgia in 1859. He moved to Tampa 30 years later and was soon elected mayor of Brooksville. Palmer was a state senator in 1896 and 1897. In 1901, he represented Tampa and District 11. He purchased Philippe Hammock in 1906. Palmer played a major role in establishing the Florida Citrus Exchange in 1909 and also formed the Safety Harbor Citrus Growers Association. While he spent most of his time in Tampa, he kept a cottage near his groves at Philippe Hammock, where he lived at least two months of the year. During Prohibition, Palmer was twice arrested in liquor raids, and on one occasion during a party, a man was murdered on his Safety Harbor property, which had to do with the shooter having had "too much wine," according to the *Tampa Tribune*. Thomas Palmer died at his home in Tampa in 1946 at the age of 87. (Courtesy of State Archives of Florida.)

COLONEL TOM PALMER

Speaks Tonight
Nov. 3, 1928
7:30 P. M.
at
SPRINGS PAVILION
HEAR HIM! HEAR HIM!

Col. Tom Palmer will speak in behalf of Al Smith's candidacy and will answer W. L. Hackney's speech made last Tuesday in the Alden Theatre.

BRING YOUR FRIENDS!

Thomas Palmer was considered one of Tampa's oldest citizens and most distinguished lawyers. He was a tough criminal defense attorney and stimulating speaker. Three days before the 1928 presidential election, Palmer invited his Safety Harbor neighbors to hear him speak on behalf of Al Smith, the Democratic nominee. Smith, the governor of New York, was running against Republican Herbert Hoover. Smith was anti-Prohibition and the first Catholic nominee of a major party. Women liked Smith; the Ku Klux Klan opposed him. Hoover won the election and became the 31st president of the United States. Pinellas County purchased Palmer's Safety Harbor property after his death. It would become Philippe Park. (Courtesy of Safety Harbor Museum and Cultural Center.)

Dr. Con F. Barth's arrival in 1924 coincided with the beginning of the Great Depression, when many homes and businesses were abandoned. Barth filled the role of superintendent of baths at the sanitarium. In 1928, he moved to the Pipkin Mineral Wells Hotel and took over their bath operation. He leased the sanitarium from 1930 until 1936, when it was sold to Dr. Albin Jansik. He then acquired the Spa Park Inn and renamed it Barth's Hotel and Baths, providing the town with another hotel and mineral health establishment. He beautified the grounds and created steam rooms, something the sanitarium did not offer. Barth was also a successful boxing trainer, who had worked with at least one middleweight champion, Albert "Buck" Crouse. Outdoor boxing exhibitions attracted many sports enthusiasts to the city. Two decades later, Con Barth served as mayor from 1950 to 1952. (Both, courtesy of Safety Harbor Public Library.)

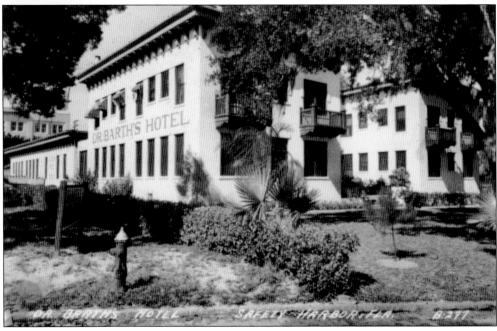

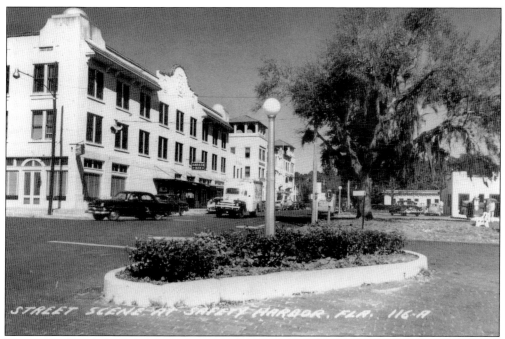

This angle shows where Barth's Hotel and Baths was in comparison to the buildings across the street and the distance between Barth's and the sanitarium. Barth's is on the right, and the Alden and DeSoto buildings are on the left. (Courtesy of Safety Harbor Public Library.)

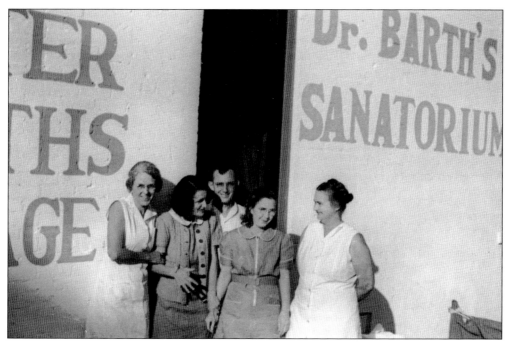

Workers pose under the Barth's Hotel and Baths sign that was painted on the side of the building. Being a spa worker meant a steady income and work that lasted year-round, except of course for the off-season, which was during the hottest months of summer. (Courtesy of Betty Joe McMullen.)

Homes and buildings were primarily made of wood in the 1800s and into the 1900s. Lanterns and fireplaces were often the causes of fires, and the only way to control them was through a citizens' bucket brigade, such as what had been attempted in 1917. A secondhand American LaFrance was purchased by the city in 1923; however, it did not always start. The local government could not afford its upkeep; in fact, all city services except basic ones through the fire department were halted. Thankfully, a little more than a decade later, a young mechanic named Bob "Vet" Morrow arrived with his family. He needed a place to work, and the department let him use a garage in back of the station as long as he kept the fire truck running. (Above, courtesy of Charles Russell III; below, courtesy of Safety Harbor Museum and Cultural Center.)

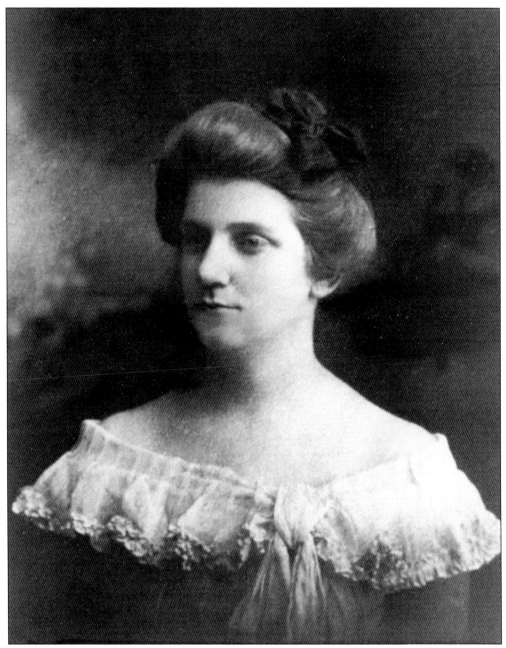

Like her mother Virginia, Susan Tucker took a leadership role in Safety Harbor, albeit unofficial. She voiced her opinions and was sometimes chastised for doing so, even indirectly referred to as "The Village Knocker" on the front page of the *Safety Harbor Herald* on May 30, 1919. She had apparently been complaining about how the city was being run. Although her name had not been mentioned, Susan seemed to know it was meant for her and wrote a letter to the editor defending herself and scolding him for name-calling. In 1929, she ran for one of three open seats on the city commission, becoming the first woman to run for public office in Safety Harbor. She came in fourth out of five candidates, with 39 votes. The top three, all men, filled the seats. (Courtesy of Heritage Village Archives and Library.)

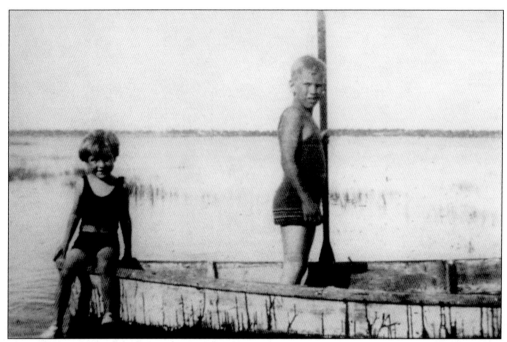

Safety Harbor has always been a wonderful place for children to grow up. In the 1930s, they had sunshine, the bay, and plenty of citrus to eat, but danger lurked sometimes too. Little Louise Barron, left, was bitten by a rattlesnake in 1931 at age five. She was taken to Morton Plant Hospital, and recovered. In the picture, she and her brother Howard pose while playing in Tampa Bay. (Courtesy of Marilyn Kirkpatrick Halsey.)

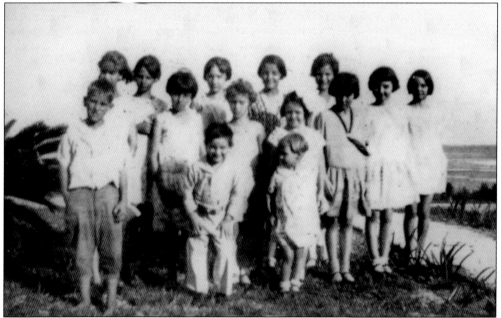

Two of the Barron children and their friends played together in front of their home on Bayshore Boulevard, north of Grand Central Avenue. Harold is at left, and in the third row, third from right, is Virginia. (Courtesy of Marilyn Kirkpatrick Halsey.)

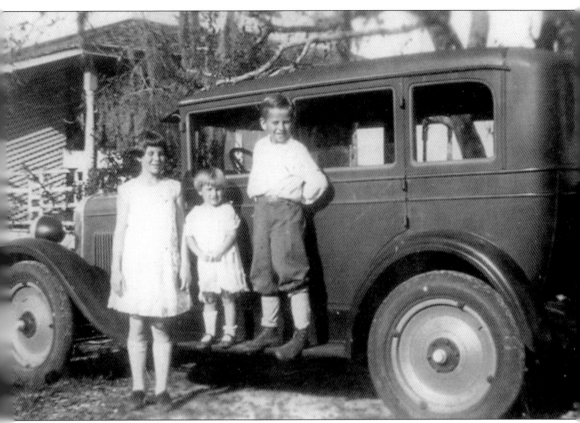

In 1930, Safety Harbor's population was 765. All children up to grade nine attended the Safety Harbor School. High school kids went to Dunedin or Clearwater for 10th through 12th grades. Birthday parties and school and church functions filled every family's calendar. Pictured are, from left to right, Virginia, Louise, and Harold Barron around 1929. (Courtesy of Marilyn Kirkpatrick Halsey.)

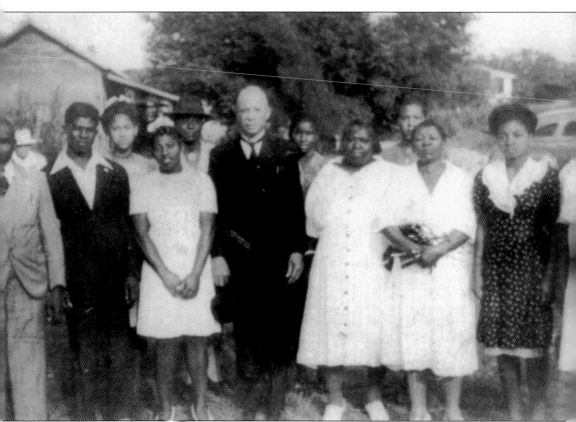

Goldie Bell Smith, later Banks, was born in Georgia to Amanda and Charlie Smith in 1918. She was so tiny and frail that her parents decided to relocate to Florida, to a town known for its healing waters. Goldie's father built a small shotgun home on Elm Street and was an important contributor to Safety Harbor's boom years. Later, when she and her younger sister Ruth were told they could not walk on the sidewalks downtown, Ruth replied that their father helped build this town so they could walk wherever they wanted, and they did. Goldie spent most of her life in a home her father built and later rebuilt. She died in 2017, just shy of 100 years old. In the photograph, young Goldie is in front, third from the left, next to Rev. Denmark Brooks. (Courtesy of Heritage Village Archives and Library.)

Three

The Harbor's Heyday

Safety Harbor is what we make it. We have everything here that nature could give any city.

—A.E. Shower, 1876–1961

Locals had already experienced difficult times prior to and through the Great Depression, so when Safety Harbor's young men felt called to action, the overseas conflicts became the conversation around every dinner table.

The mayor and commissioners organized blackout drills and first-aid classes. The *Safety Harbor Herald* called for everyone to plant a Victory garden to ensure no one would go hungry. The previous decade had proven it was possible.

Returning servicemen found that Safety Harbor had not changed much; however, they had. The women who had previously found work and enjoyed it were now marrying and starting families. Many women secretly missed their jobs. A few broke through traditionally male roles and began careers of their own.

In 1945, Dr. Salem Baranoff arrived from New York, focusing on the benefits of proper diet and physical fitness and helping clients to learn how to minimize the effects of the aging process.

A total of 150 clients came to Safety Harbor during Dr. Baranoff's first season at the spa. Upon arrival, guests received a physical examination and were assigned individualized diets as well as a variety of exercises, massages, and whirlpool baths. The former St. James Hotel, renamed the De Soto Hotel, was used for guests.

Baranoff employed primarily Safety Harbor, Clearwater, and Oldsmar residents. Wealthy guests tipped well, so spa jobs were filled quickly and most employees kept their positions.

The spa closed for the off-season beginning in April. All of the normal hubbub halted. By the end of summer, there would be weeds growing waist high through Main Street's bricks.

The late 1940s brought a new library for Safety Harbor. The little city now had everything residents needed, including grocery stores, a pharmacy, and a hardware store, and there was always the pier, where children would spend long summer days diving into the bay.

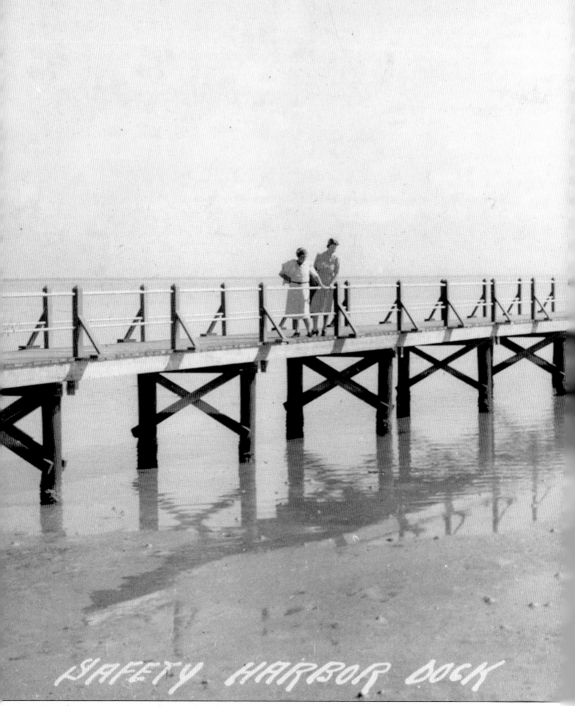

SAFETY HARBOR DOCK

For close to 140 years, the pier has been an iconic part of Safety Harbor's character. In the 1800s, boats docked and travelers were welcomed. No matter its size or specific location, the pier's stretch into the bay has served as a neighborly meeting place for many generations—a place to watch the sunrise or to greet gentle manatees as morning shifts to noon. Dance halls, a bait shop, fishing

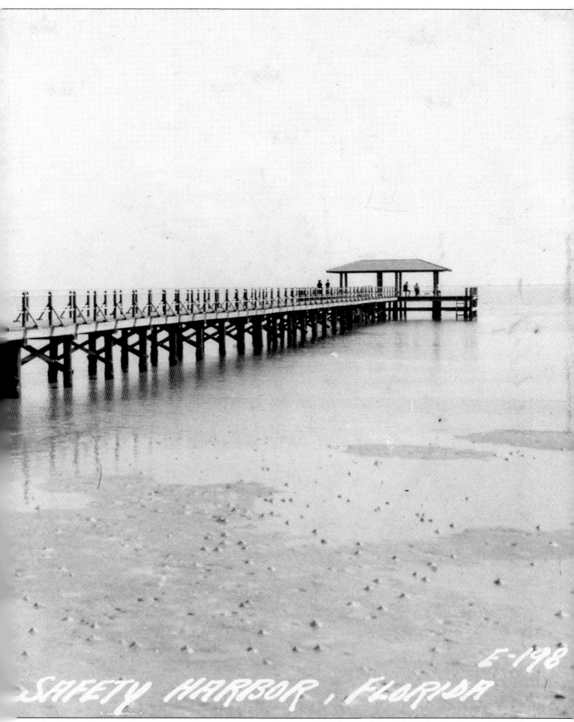

docks, and even a bar once took up space on the pier. Children of the 1960s had a diving board at the end to relieve the heat of long summer days. More recently, there have been concerts, marriage proposals, and thousands of photographs, and as generations continue, it will always be a place to create special moments. (Courtesy of Heritage Village Archives and Library.)

This pump was located under a canopy over a spring at Alligator Creek. People would bring their own jugs, pull to the side of the road, and fill the jugs with spring water to carry home. (Courtesy of Betty Joe McMullen.)

Early residents crossed over the mouth of Mullet Creek on a wooden bridge until 1926, when Pinellas County commissioners voted to replace it with a substantial concrete structure. In 1938, funding through the Works Progress Administration provided 25 workers for three months for the creek to be "widened, deepened and straightened." (Courtesy of Betty Joe McMullen.)

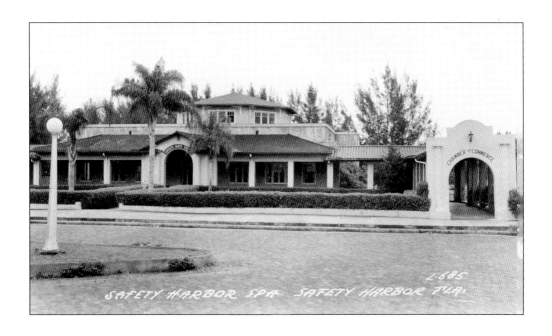

In 1930, the Safety Harbor Chamber of Commerce formed to promote local business. The chamber and visitor's center occupies the oldest surviving building on Main Street, which previously served as town hall and the Espiritu Santo Bank, Safety Harbor's first bank. For a short time, the chamber of commerce was located at the spa, and during World War II, it sometimes met in church halls. Eventually, the chamber permanently moved to the historic 200 Main Street building that has survived both fire and hurricane. (Above, courtesy of Safety Harbor Public Library; below, courtesy of Betty Joe McMullen.)

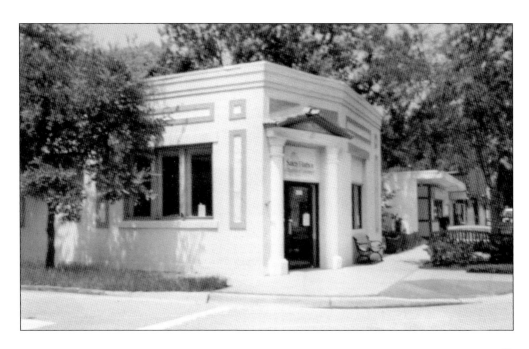

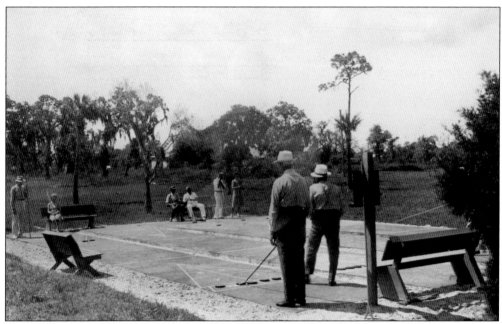

Shuffleboard courts appeared in town in the late 1920s through funding from the Works Progress Administration. The sport's popularity increased for both men and women. Teams were formed, and events were often covered by the *Safety Harbor Herald*. The pastime was a perfect escape during World War II as it allowed the older generation to think of something other than those who were far from home. (Courtesy of Betty Joe McMullen.)

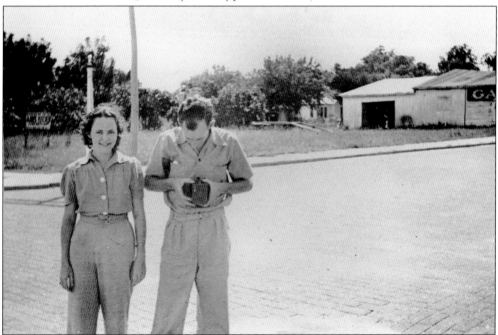

Dorthy and her husband, Louis Aunspaugh, son of Joe Aunspaugh, were captured in a photograph before Louis could aim his own camera. One of the city's garages can be seen behind them. (Courtesy of Betty Joe McMullen.)

Safety Harbor's African American churches provided community support, social functions, and mentorship. In this photograph, Lillie Brooks (right), wife of pastor Denmark Brooks, stands with their daughter at their home on Cedar Street. (Courtesy of Heritage Village Archive and Library.)

Looking southeast from atop the Alden Apartment building, a real estate office was on First Avenue, now Philippe Parkway. To the right was a filling station, and across the street were the sanitarium and the Espiritu Santo Springs pavilion. Directly in view across First Avenue was Barth's Hotel and Baths. (Courtesy of State Archives of Florida.)

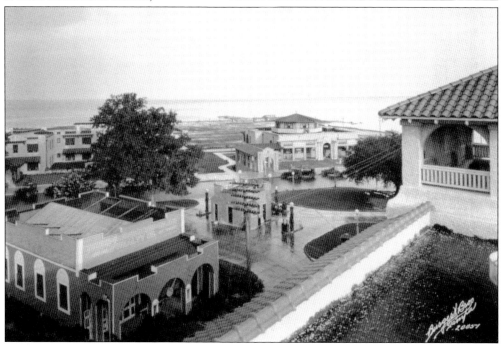

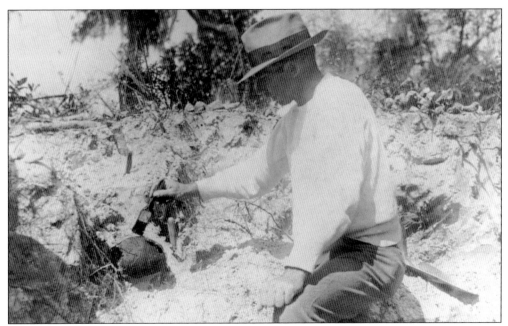

The area once called Philippe Hammock, now Philippe Park, was owned by Thomas Palmer beginning around 1906. Palmer did not allow archaeologists to excavate the burial mound there until 1930, when the Smithsonian Institution's Bureau of American Ethnology chief, Matthew W. Stirling, was granted permission to dig. An average of 20 skeletons were unearthed every day of the excavation, with one source saying over 1,400 were recovered in total and another claiming only 500. The bones revealed that the residents of this village were a medium-statured, muscular people with good teeth, indicating a healthy diet. The burial mound, which no longer exists, had three levels and stood 15 feet high. Stirling returned to the Smithsonian with 300 skeletons, while those left at the site were allegedly taken by local farmers to grind and use for fertilizer. (Both, courtesy of Safety Harbor Museum and Cultural Center.)

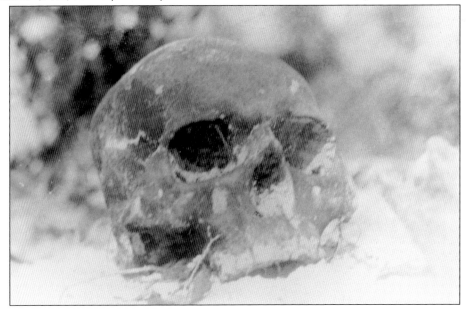

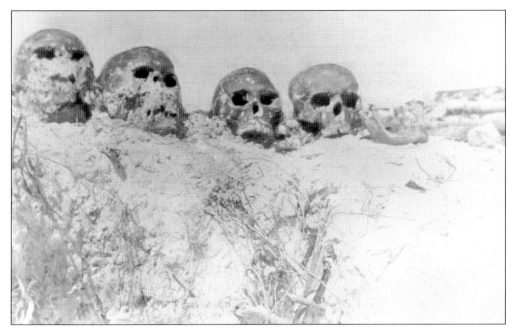

While the skeletal remains were the most exciting part of Matthew Stirling's discoveries, there were also Spanish artifacts dating from the 16th century, including an iron axe with a curved blade and European pipe bowls, which suggested that Europeans had indeed visited the Tocobaga village. (Courtesy of Safety Harbor Museum and Cultural Center.)

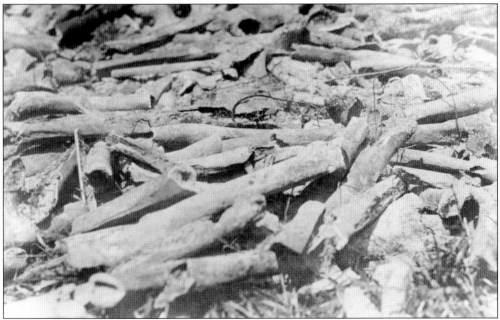

Besides bones, Stirling also unearthed a large amount of pottery, mainly from the base of the mound near its edge. This style of pottery (not pictured), which is often found at Tocobaga archaeological sites, is now known as Safety Harbor Incised. In the 1970s and 1980s, when many new homes were built, skeletal remains were sometimes found when holes were dug for swimming pools. (Courtesy of Safety Harbor Museum and Cultural Center.)

Ben Davis began building a causeway across Tampa Bay in 1930, which provided jobs for many locals. It was completed in 1935 as a toll road; at the time, it was the longest span across a body of water in the United States. Since it bypassed Safety Harbor for Clearwater, fewer people had reason to pass through, which became a detriment to Safety Harbor's tourism. (Courtesy of Betty Joe McMullen.)

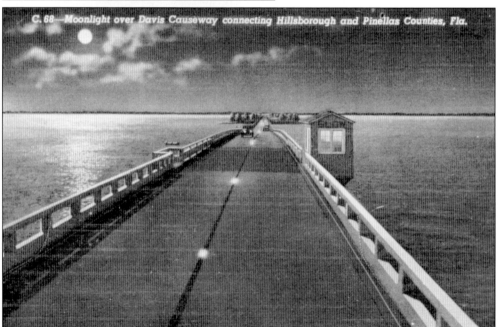

The Davis Causeway project is estimated to have cost $1.5 million at its completion. In 1944, it was purchased by the state roads department and federal government and became toll-free. It was renamed after Courtney Campbell in 1948 to honor the interest he had shown in landscaping the roadway. (Author's collection.)

In 1935, the country was in the middle of the Great Depression. Still, in Safety Harbor, there were occasional land auctions and community gatherings. Children performed and played games, and adults listened to presenters or sermons. (Courtesy of Danny Hill.)

Friday night entertainment at Safety Harbor Junior High School was a popular social event, even for those who were not parents. Like today, local businesses played a large role in supporting community events. For many years, grocery stores outnumbered most other types of retail businesses in town. (Courtesy of Betty Joe McMullen.)

GIBSON'S SERVICE STATION	TWITCHELL'S GROCERY	
Good Gulf Gas Gulf Pride Oil	Woco-Pep Gas & Oils Groceries & Meats	Compliments DR. BARTH'S HOTEL AND BATHS
Batteries — Federal Tires	Corner 10th Ave. and Main St.	
L. H. ZINSSER REAL ESTATE—INSURANCE RENTS—BONDS Complete Insurance for Your Home, Car and Your Life	**ENTERTAINMENT** SAFETY HARBOR JUNIOR HIGH SCHOOL AUDITORIUM FRIDAY JANUARY 31, 1936 8:00 P. M.	SAFETY HARBOR HERALD Keep Posted on Local Affairs SPECIAL OFFER $1.00 PER YEAR
Compliments LOWELL'S CASH GROCERY	ADMISSION Adults 15c — Children 10c Program Junior High School Orchestra Cecil Chambers, Charles Chambers, H. L. Keel. Miss Katherine Culpepper, Director.	K & T SERVICE STATION Texaco Gas Havoline & Quaker State Oils Goodyear Tires J. L. KINDRED, Prop.
Compliments "POP" RANDALL'S COFFEE SHOP	PLAYLET—"YOURS AND MINE" Katherine Fox Flowers, the wife — Ruth Schneible Dr. James Flowers, the husband — Olivia Burnette Dad Flowers, the father — Olive Mae Tyson Mrs. Hopper, the widow — Mary Ellen Rountree SCENE: The living room of Dr. Flower's home in a North Carolina town. TIME: The present.	Compliments ST. JAMES BARBER SHOP J. S. Pearce, Prop.
LASHER & SON Feeds, Groceries & Meats	SONG—"TRAVELIN' MAN" Wilma McMullen, Shirley McMullen, Mary Thomas, Marie Burnette. READING—"A CULLERED LADY AT THE TELEPHONE" Wilma McMullen A STUNT—"AN OPERATION" Doctor — Clarence Kindred Nurse — Florence Parrish Patient — Allen McMullen Junior High School Orchestra SELECTIONS	OWENS I. G. A. STORE Groceries, Meats Fresh Vegetables
BARRON'S DRUGS Cold Drinks, Candies Tobaccos	Program arranged and directed by Miss Katherine Culpepper and Miss Phebe Whiting. Programs through the courtesy of the merchants and business men whose advertisements appear. P-T. A. Will Sell Cake & Ice Cream in Hall After Program	SILVER DOME CAFE Regular Meals & Short Orders Good Cooking Reasonable Prices

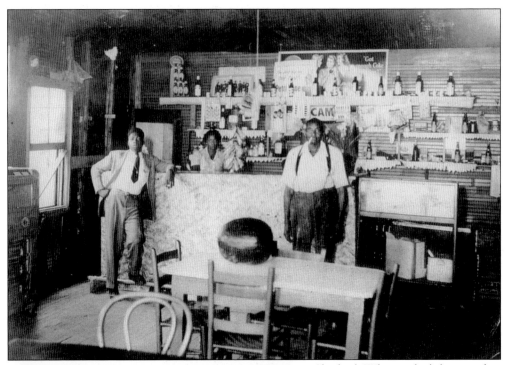

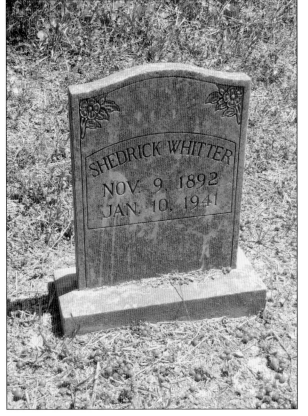

Shedrick Whitter, far left, owned a general store and beer garden in Safety Harbor's African American community. Whitter was also an inventor who, at age 25, filed a patent for an electrical wire support tree. The patent was later awarded to him. Whitter married Maud Ellis in March 1916, and they had seven sons. (Courtesy of Heritage Village Archives and Library.)

On October 10, 1936, Shedrick Whitter overheard 19-year-old Leonard Henry threaten his son. After a confrontation, Whitter shot Henry, killing him. The mayor of Safety Harbor and the constable both served as character witnesses during his trial, but Whitter was sent to prison, where he died four years later at the age of 48. He is buried at Whispering Souls African American Cemetery. (Courtesy of Lou Claudio.)

After Shedrick Whitter's death, Maud Whitter was left to handle the details of their business and finish raising their four youngest sons, aged 7 to 14. Maud was a member of the Bethlehem Baptist Church and had a community of friends and supporters. (Courtesy of Heritage Village Archives and Library.)

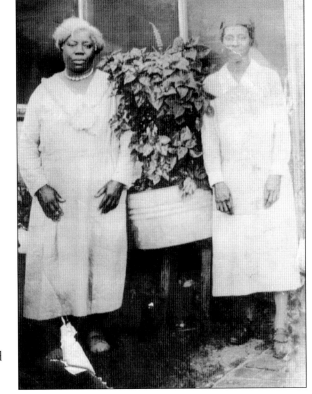

City directories indicate that Maud Whitter continued running the grocery store, and one of her sons later opened a barbershop. Neighborhood children loved going to "Miss Maud's," where they could buy cookies or treats for just a few cents. In this photograph, she stands at left next to an unidentified woman. (Courtesy of Heritage Village Archives and Library.)

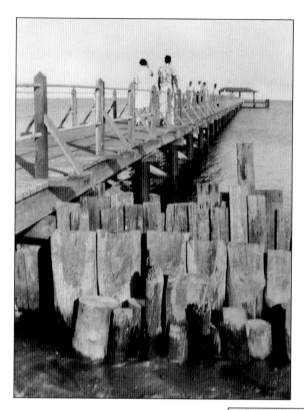

In 1935, a massive hurricane hit Florida, devastating the Keys and surrounding areas. Tampa Bay experienced extensive damage too, and the Safety Harbor pier was destroyed. This photograph likely shows the pier soon after it was rebuilt. (Courtesy of Richard Aunspaugh.)

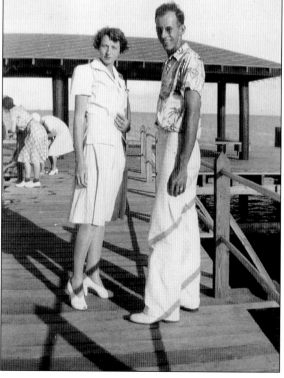

While this photograph was taken almost a century ago, the same appreciation for manatees, dolphins, and Florida weather endures. Standing on the pier, siblings Elanor and Louis Aunspaugh were captured in time on a beautiful day. (Courtesy of Richard Aunspaugh.)

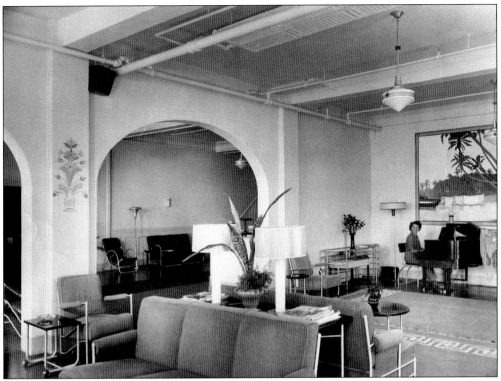

In 1936, Dr. Alben Jansik purchased the springs, sanitarium, and the St. James Hotel at a tax sale for $17,000. He renovated the existing structures, redecorated, improved the landscaping, and created recreation facilities, including lawn tennis and shuffleboard courts. Over the next several years, the facility's popularity increased due to Jansik's focus on diet, exercise, and rest. This is the renovated hotel lobby. (Courtesy of Heritage Village Archives and Library.)

Prior to the war, the sanitarium had become a destination for wealthy families and celebrities, including Harry Houdini's widow, department store founders F.W. Grant and Russ Kresge, the family behind Seagram's, and many others. Jansik heavily advertised the hotel's amenities, including the new decor in the rooms. (Courtesy of State Archives of Florida.)

83

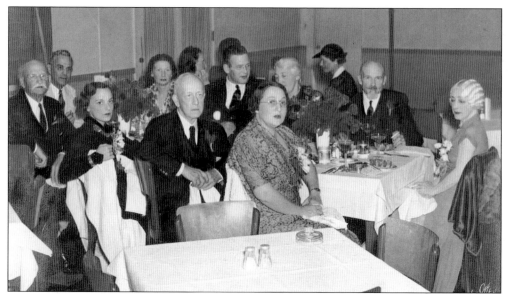

Bess Houdini (far right) frequented the sanitarium in the late 1930s. Pictured with her are, from left to right, (first row) Dr. W.P. Eldridge, Mrs. Eldridge, W. Meyers, and Hazel Kindred; (second row) Safety Harbor mayor L.H. Zinsser, Hattie Zinsser, former senator W.L. Hill, Mrs. W.L. Hill, and Dr. Edward Saint. The birthday dinner was held in Clearwater to honor Mrs. Zinsser and Dr. Saint. (Courtesy of Safety Harbor Museum and Cultural Center.)

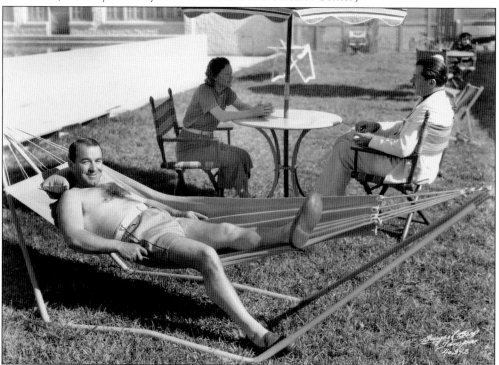

Professional golfers and their wives visited the sanitarium prior to their participation in a tournament in Belleair in 1937, including Gene Sarazen (smiling at the camera), who at the time was one of the world's top-ranked players. (Courtesy of Tampa-Hillsborough County Public Library System.)

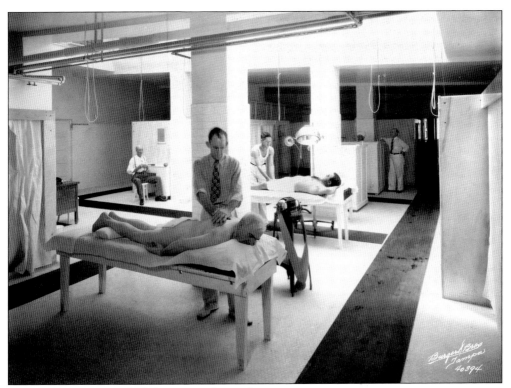

Dr. Jansik's sanitarium had the newest diet and exercise programs, including a food-combining diet called the Hey Method. Dieticians and nurses trained in the methods were on staff at all times, according to a *St. Petersburg Times* advertisement, which also mentioned weight loss treatments through "hyperlexia (artificial fever), short and ultra short wave, diathermy and a complete schedule of baths and manipulative treatments." (Courtesy of Tampa-Hillsborough County Public Library System.)

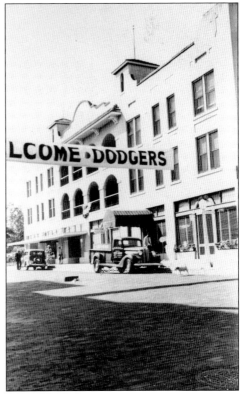

During one unforgettable week of spring training in 1940, the entire Brooklyn Dodgers team stayed at the Santo Springs Hotel (formerly the St. James Hotel). It was an exciting thing for locals to focus on, especially with the escalating national fear of war. By the early 1940s, the hotel primarily operated as an alcoholism rehabilitation facility. (Courtesy of Betty Joe McMullen.)

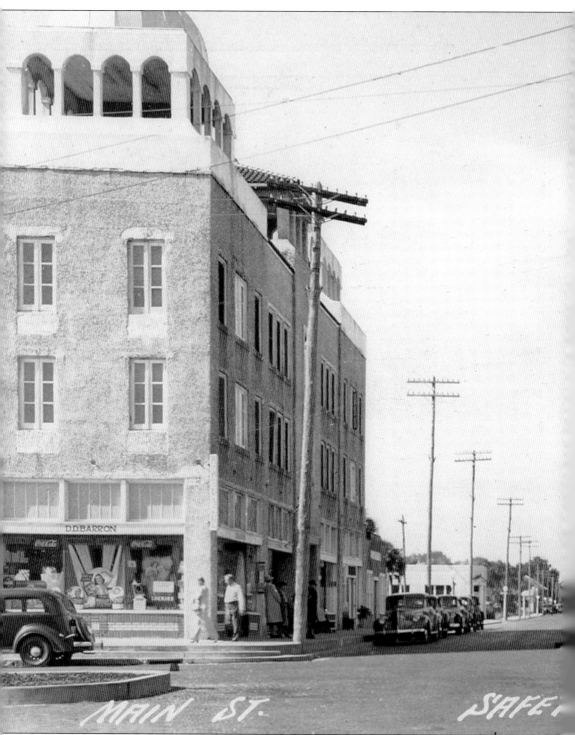

Main Street in the late 1930s and early 1940s was not the busy city center that it is today. By the time the United States got involved in World War II, every young man who was able to—and a few young women—left Safety Harbor to fight or contribute to the war effort. The Depression

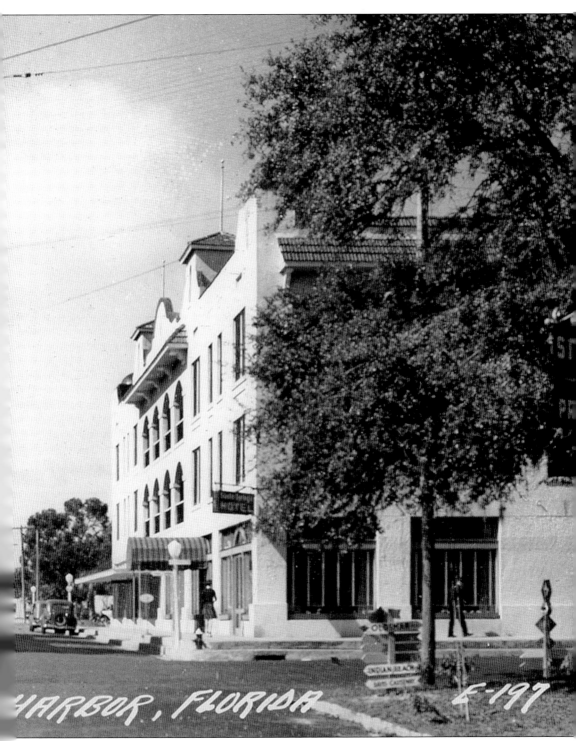

had affected everyone. Prior to the war, many young men could be found sitting on the southwest corner of Main Street and Philippe Parkway outside of Doc Barron's Drugstore, reminiscing about their youth, which had not been that far back. (Author's collection.)

After the 1917 fire destroyed his wooden drugstore building, David "Doc" Barron (1885–1949) set up shop in another space on Main Street. He is shown here with two of his children around the time that a new, prime location became available. (Courtesy of Marilyn Kirkpatrick Halsey.)

Doc Barron moved into the Washburn Building on the southwest corner of Main Street and what is now Philippe Parkway. He passed the business on to his son Howard around 1947, but he died only two years later at the age of 63. (Courtesy of Marilyn Kirkpatrick Halsey.)

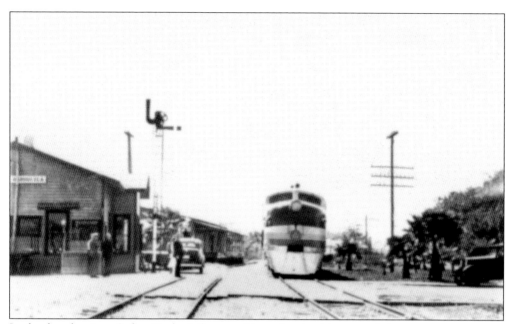

In the decades since Safety Harbor's first northbound train shipment of citrus, passenger service increased greatly. The first diesel train stopped in Safety Harbor in 1943. Times were changing, and fast passenger trains were popular, especially for winter tourists traveling from afar. (Courtesy of Safety Harbor Public Library.)

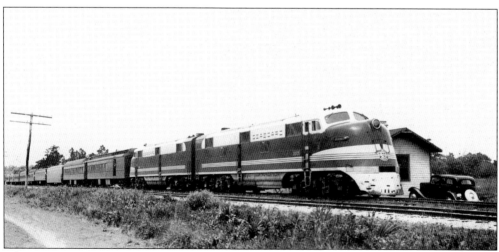

Glenn O. Petree was the sole station agent between 1925 and 1963. A railroad man through and through, he worked without direct supervision and was highly respected for his dedication to the railroad. Petree also served as the telegraph operator, which was likely a difficult responsibility during World War II. (Courtesy of Heritage Village Archives and Library.)

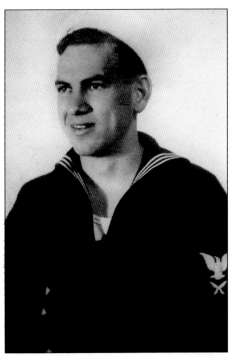

Howard Barron, along with approximately 140 Safety Harbor men and a few women, left home to join the war effort. Safety Harbor lost five men, including two brothers, and the city grieved. Those at home tried to support the soldiers, sailors, and marines overseas. Care packages and letters went to every service member. Blackout drills were organized, and Victory gardens were planted. (Courtesy of Marilyn Kirkpatrick Halsey.)

Those who returned home needed support. In 1944, the fathers of the first two men lost in World War I and World War II formed the Lawton-Herrington American Legion Post to honor their sons, Carl Lawton (World War I) and Cecil Harrington (World War II). This American Legion Post was chartered in 1962 and became Post 238. It is located at 900 Main Street. (Courtesy of State Archives of Florida.)

The country felt relief and pride when the war ended. They looked forward to their loved ones returning home. Some who returned home married right away. Others struggled. Many sat on the same corner as they had before the war. There were no jobs waiting for them. (Author's collection.)

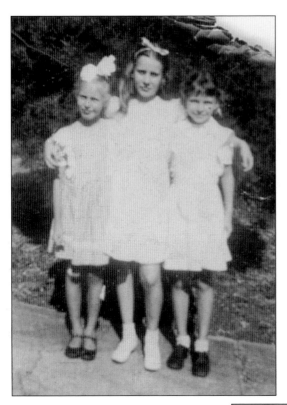

These Safety Harbor friends were likely dressed for a party or special event. From left to right are Betty Joe McMullen, Sally Lou Jansik, and Emmajean Pedigo. Betty, the great-granddaughter of James P. McMullen, would bring flowers from her mother's garden to the local butcher to sell from his meat counter. Sally was the daughter of Albin Jansik, who owned the sanitarium. Emmajean was descended from the Booth family. (Courtesy of Betty Joe McMullen.)

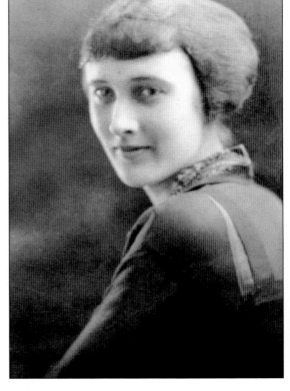

Safety Harbor's first woman city manager was Mary Ingersol, who had held the position for a year during World War II. In 1947, Ida Samuelson (pictured) was the only woman city manager in Florida and one of just a few in the United States. She was applauded for "having a housewife's touch." She remained in the position until 1958. Samuelson died in 1976 at the age of 78. (Courtesy of Sherri Glassner.)

Louis Zinsser was a successful Safety Harbor real estate man who kept office space on Main Street for many years. Prior to his death, he donated land near the marina, which was designated to be used as a park. Zinsser was a lifelong mason and served as mayor from 1929 to 1932 and 1944 to 1946. He died in 1977 at 90 years old. (Courtesy of Safety Harbor Public Library.)

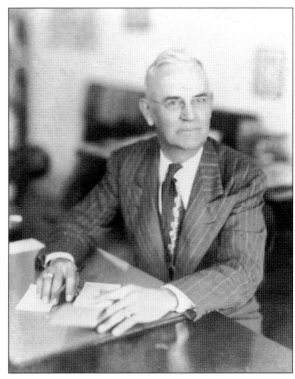

This is a view of Main Street looking north-northwest. On the property across the railroad tracks on the right, the Rigsby family had planted a Victory garden during World War II. Later, it became the site of Frostee Harbor, followed by the Whistle Stop Grill & Bar in the 1990s. (Courtesy of Safety Harbor Public Library.)

In the early 1940s, the Pinellas County Commission and the Soil Conservation District worked to get the Alligator Creek project completed. By the end of January 1948, Alligator Creek had become Alligator Lake. While there were several issues with the dam breaking and valuable fish dying, in the end the creek attracted birds and wildlife back to the area. (Author's collection.)

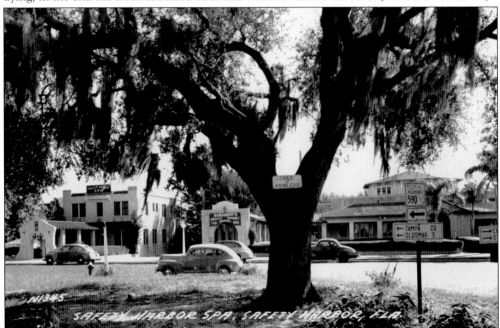

Dr. Jansik hired Dr. Salem Baranoff to assist him in running the sanitarium and hotel in the winter months. Mounting expenses and lack of tourism forced Dr. Jansik to sell in 1945. It was purchased by Dr. Baranoff and a group of New York investors and became the Safety Harbor Spa. The "Tree of Knowledge" sign seen here was added for local teens who often sat under it, "solving the problems of the world." (Courtesy of Safety Harbor Public Library.)

Dr. Salem Baranoff was a soft-spoken, generous man whose work centered on natural health. He was loved by his Safety Harbor neighbors and immediately became an active member of the community. In this photograph, he stands with Ronnie Chambers, a Safety Harbor resident. (Courtesy of Betty Joe McMullen.)

Dr. Baranoff funded scholarships in English and mathematics for Safety Harbor Junior High School students. He donated the American Legion building after World War II, and when he learned of the city's need for a library, he donated land to build one. A groundbreaking ceremony for the new building was held on November 18, 1949. Salem Baranoff died in 1977 at the age of 90. (Courtesy of Safety Harbor Public Library.)

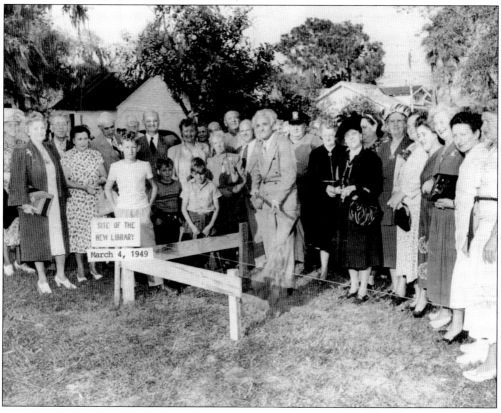

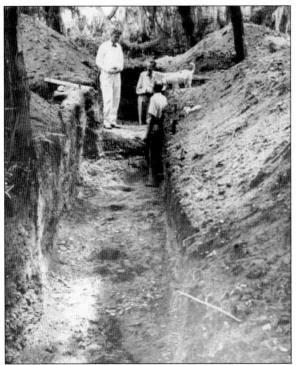

Following landowner Thomas Palmer's death, Pinellas County established Philippe Park in 1948. Florida Parks Service archaeologists Ripley Bullen and John Griffin began excavations. They unearthed Tocobaga stone tools and pottery as well as European artifacts. (Courtesy of Kelly Griffin.)

The Safety Harbor Lions Club was formed on April 3, 1950, "to create and foster a spirit of understanding among all people for humanitarian needs." Pictured are, from left to right, (first row) Gary Linton, Harold Barron, Jim Haslam, Roy Clement, Harry Kindred, and Fred Stoll; (second row) Robert Thurman, Angelo Foster, Dwight Shower, Bill Blanchard, Dr. S.H. Baranoff, and Clyde Rigsby. (Courtesy of Safety Harbor Public Library.)

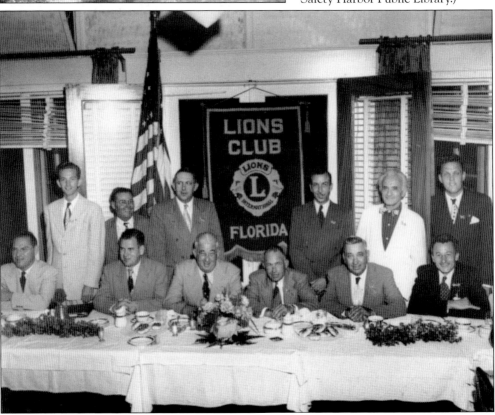

Members of the Bethlehem Baptist church choir took a moment for a photograph. From left to right are (first row) Azaline Smith, Rosetta Williams, Goldie Bell Banks, and Roosevelt Gibbs; (second row) Marcus Lang, Daisy Douglas, and Joyce Thomson; (third row) unidentified, Ruth Hayes, and Shirley Whitter; (fourth row) Marjorie Townsend, Jesse Brown, and G.C Whitter. Daisy Douglas is the namesake of the city park at 601 Ninth Avenue North. (Courtesy of Heritage Village Archives and Library.)

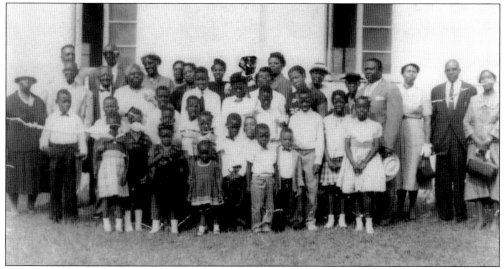

The Bethlehem Baptist congregation included Charlie and Amanda Smith. Charlie stands in the back, second from left, wearing sunglasses. Amanda is under the window, fifth from right, wearing a black hat. Charlie and two others founded the St. Paul Helping Hand Society. The Smiths' legacy lives on through the recent Whispering Souls African American Cemetery restoration project, led by their granddaughter Jacqueline Hayes, who they never met. (Courtesy of Heritage Village Archives and Library.)

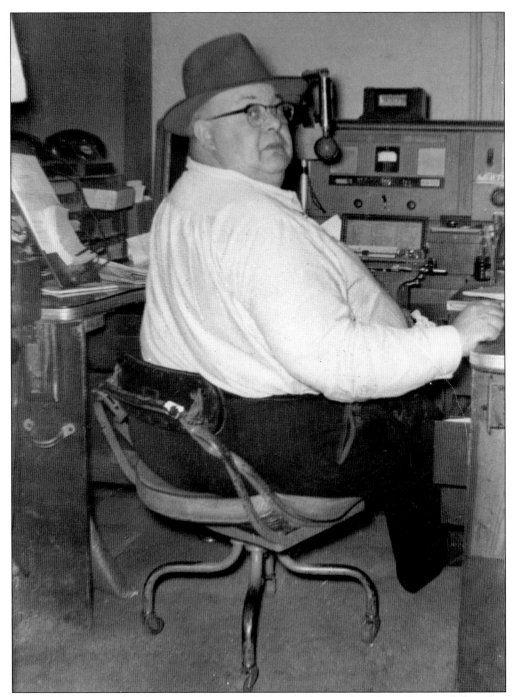

Howard Benson was hired in 1946, becoming Safety Harbor's only police officer and therefore chief of police. Chief Benson contended with citizens' complaints for years before resigning in 1950. One complaint was that he called on Constable Percy Vasbinder to make arrests. In Benson's defense, there was nowhere in town to house a prisoner, as the only jail was at the county courthouse. (Courtesy of Howard Benson Jr.)

Four

Mid-Century to Millennium

Everybody has a story, and everybody deserves the opportunity to tell their story before you judge them.

—William Blackshear (1935–2021)

City politics were volatile in the late 1950s. One city commission meeting was reported to have become violent when the mayor attempted to fire the police chief.

Old and young came out for parades on Main Street as well as for pageants and school plays.

The first African American person to hold public office in Florida since Reconstruction was elected to the commission in 1964. Segregation ended, and all of Safety Harbor's children were soon able to attend school together. The Lions Club was chartered, and the American Legion assisted veterans. Historical reenactments were popular, as were school plays and matinees at the local theater.

On December 7, 1972, the Harbor State Bank at 550 Main Street was robbed at gunpoint. A police officer was injured, and the getaway driver was killed. For a while, residents wondered what had happened to their tranquil town.

A festival committee comprised of 11 organizations began planning for a celebration that would include aerialists, mechanical rides, games, and a skating rink. This event perhaps propelled a love of festivals that would carry into the next century.

Antique store owner Lois Spencer worked with the museum to organize the city's first Seafood Festival, which positively impacted local businesses, prompting the formation of a Third Friday planning committee.

Hurricane Elena disrupted the city on September 1, 1985, destroying the pier. Not long after, $88,000 was spent on repairs, and two young men drove a stolen car onto the pier and set the car on fire.

The 1980s also brought additions to the library, a recreation department, a community center, and a gazebo at John Wilson Park. Safety Harbor repaved roads and created parks in the 1990s. A new library building opened in 1994, and the Rotary Club was chartered in 1996.

Residents still protested when they did not approve of decisions made by the commission but that holds true for any decade in Safety Harbor: people are passionate about why they live here and what they love about their city on the bay.

Edward Jameson lived in Safety Harbor from 1941 to 1966, when he died at the age of 85. He spent every moment he could fishing and held the proud title of dock master. He would become an iconic figure to kids who lived in Safety Harbor during those years because they, too, were always at the dock, fishing or jumping into the bay on hot summer days. (Courtesy of Heritage Village Archives and Library.)

Mainly due to destruction from storms, the pier has been replaced several times over the past century. The pier once hosted a bait shop. There was also a bar near the marina, known for bringing in a tough crowd after dark. Young people met at the pier every day to swim during the summer. A separate fishing dock allowed for net or line casting. (Courtesy of Safety Harbor Public Library.)

From its conception in 1938, to Salem Baranoff's land donation, to its grand opening, Safety Harbor's library served many generations. In this 1949 photograph of the inside of the new building, librarian Blanche Weagraff helps a patron check out a book. She was the librarian from 1943 to 1956. (Courtesy of Safety Harbor Public Library.)

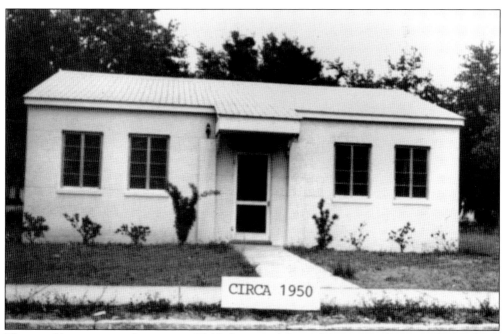

The new library was on the corner of Fifth Street and Second Street North. It was also used as a community meetinghouse. Since funding from the Works Progress Administration had ceased in 1942, the Women's Civic Club covered the costs of the library thereafter by seeking donations and hosting fundraisers such as tea parties and bake sales. (Courtesy of Safety Harbor Public Library.)

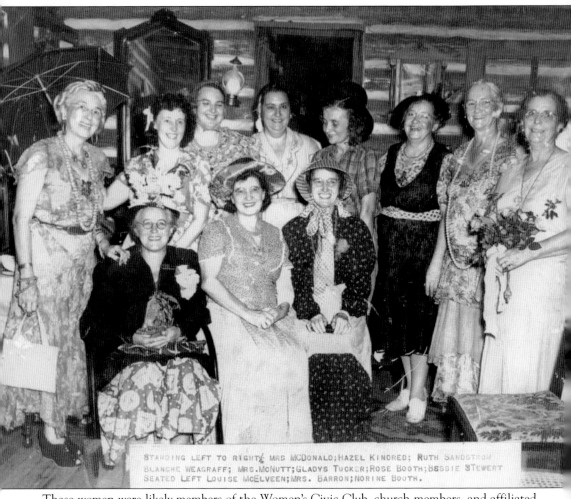

STANDING LEFT TO RIGHT: MRS. MCDONALD; HAZEL KINDRED; RUTH SANDSTROM; BLANCHE WEAGRAFF; MRS. MCNUTT; GLADYS TUCKER; ROSE BOOTH; BESSIE STEWERT. SEATED LEFT LOUISE MCELVEEN; MRS. BARRON; NORINE BOOTH.

These women were likely members of the Women's Civic Club, church members, and affiliated with a woman's lodge or fraternal organization. Not only did this establish lasting friendships, but the community also greatly benefited from their efforts. This ladies' tea was hosted at Safety Harbor's historic log cabin home. (Courtesy of Betty Joe McMullen.)

In the 1950s, Safety Harbor was a sparsely populated city with acres of wooded areas, perfect for hiding stills. On this particular day in November 1953, Sheriff Sid Saunders and his deputies found 900 gallons of mash on property belonging to a Safety Harbor man. Here, Sheriff Saunders (left) and Constable Percy Vasbinder are pictured with two of the stills they found in a backyard shed. (Courtesy of Florida Sheriffs Association.)

Located in what used to be unincorporated Pinellas County, the Kapok Tree was a popular Safety Harbor tourist attraction. It originated in India and was planted in the late 1800s by citrus grower Robert Hoyt. As seen in this photograph, a vegetable stand was near the tree in the 1950s. It is located at 923 McMullen Booth Road at the entrance of the former Kapok Tree Inn, now a music store. (Author's collection.)

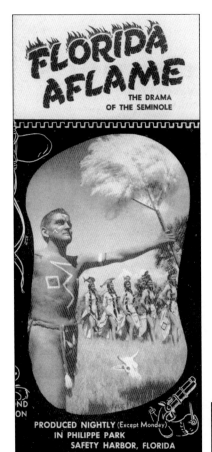 In April 1954, a call for 50 cast members was released for a new production to be staged in Philippe Park. The only thing needed was to raise $30,000 above the funding already allocated by producers. They planned to build an amphitheater at a cost of $65,000. (Author's collection.)

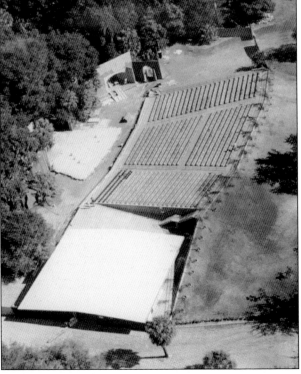

The amphitheater built south of the Tocobaga mound was completed in 1955. Seminole Indians were hired to fill roles, and actor Kelton Garwood starred in the play, written by John Waldron Caldwell. Well-known dancer Barton Mumaw choreographed and performed in the production. (Courtesy of Kelly Griffin.)

Audiences did show up for *Florida Aflame*, but the production lost money and ended abruptly. Originally, the plan was for the production to travel to cities throughout Florida; however, it ended prematurely in Philippe Park. (Courtesy of Kelly Griffin.)

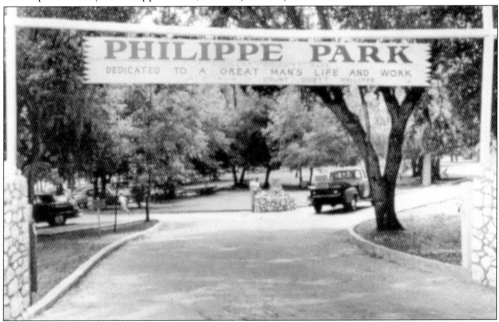

In July 1956, a white Philippe Park attendant allowed a carload of African Americans into the park because they wanted to have a picnic. Not ever having experienced what many park officials considered a challenge, the employee set up a table for them behind an Indian mound. It was a topic segregated Pinellas County had to face: if parks were meant for all citizens, it meant the Park Advisory Board would have to make changes. Their solution was to create separate picnic areas for African Americans. (Courtesy of Kelly Griffin.)

Salu Devnani came to Safety Harbor as a young man. He approached Dr. Baranoff's business partner for a job. Devnani was asked if he could teach yoga, and he said he could, but in truth, he had never attempted it. He soon learned, though, and continued to learn as he also taught. He was well liked by the spa's clientele, and within a few years, he became a successful manager under Dr. Baranoff. (Author's collection.)

Ben Downs was a Safety Harbor grocer and served as mayor from 1956 to 1960 and from 1962 to 1964. The city's politics have always incited passion in residents. It was no different for Ben Downs. In 1956, he declared a citywide emergency, firing two city employees. A court ruled that he was not authorized to do that, and the employees were reinstated. He survived a recall election. (Courtesy of Safety Harbor Public Library.)

Louise and George Ellis were lifetime Safety Harbor residents. George was a respected gardener, known throughout the city. Louise was also a proficient gardener and won many first-place ribbons at the county fair for her vegetables. (Both, courtesy of Heritage Village Archives and Library.)

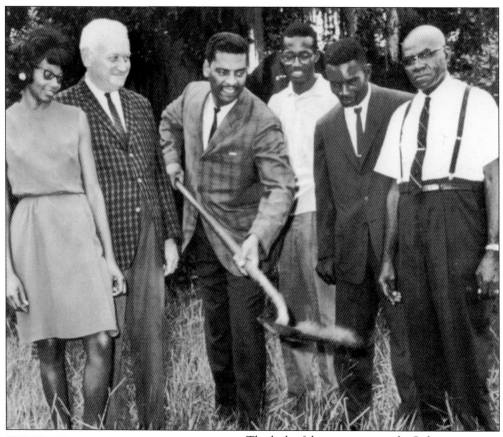

The lack of day care services for Safety Harbor's African American children affected William "Bill" and Betty Blackshear, parents of six children. Bill served as Parent-Teacher Association president for Lincoln Elementary and helped form the Lincoln Nursery Association. After finding help from a community service organization, he was soon breaking ground for the day care. With desegregation, the day care evolved and later became the Mattie Williams Neighborhood Family Center. (Courtesy of Safety Harbor Public Library.)

At age 29, William Blackshear had made connections with town leaders like George McGonegal (pictured), who encouraged him to run for office. McGonegal was sworn in as mayor on November 10, 1964, the same day that Blackshear was elected as city commissioner, winning by 22 votes. He was the first African American person to hold a political office in Florida since Reconstruction. (Courtesy of Safety Harbor Public Library.)

In 1965, President Johnson invited to the White House approximately 40 Southern African Americans in public office. William Blackshear was one of them. Among other actions, he had worked to get a train signal installed downtown after a young man was killed by a train. In this c. 1976 photograph, Blackshear (left) and colleagues pose to commemorate the new city hall. The commission chamber was named for him in 2022. (Courtesy of Safety Harbor Public Library.)

Besides serving as a city commissioner, William Blackshear was also a veteran and worked for General Electric on the Atomic Energy Commission contract. In 1967, he partnered with Cleveland Johnson to establish the *Challenger*, a St. Petersburg newspaper for and about the African American community. He became a successful advertising salesman and eventually helped expand the newspaper. He died in 2021 at the age of 85. (Courtesy of Safety Harbor Public Library.)

Frostee Harbor was the place to hang out for teenagers in the 1960s. The little ice cream shop at 915 Main Street was opened by Jane and Henry Fox in 1959. Locals knew that if Henry was working, he would look out of a blackened window with a small peep hole to see who was waiting. If he chose to serve them, orders for ice cream or hamburgers were taken from a different, side window. (Courtesy of Nyla Jo Hubbard.)

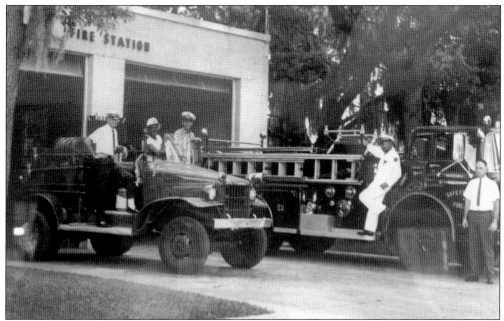

In the first few years of the 1960s, the Safety Harbor Fire Department adopted a fire prevention code. Fire-preventative clothing and a new pumper were purchased. When Hurricane Gladys struck the area in 1968, the all-volunteer department was well prepared for duty. (Courtesy of Charles Russell III.)

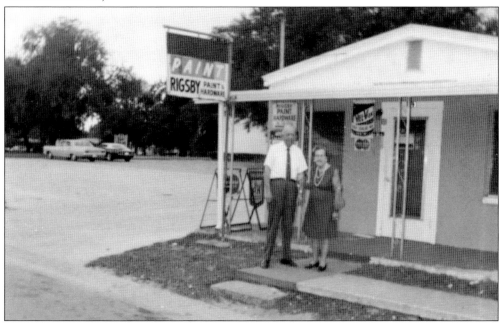

This small building at 143 Seventh Avenue North was first owned by Herman and Eva Rigsby (pictured) and served the community's paint and hardware needs well into the 1970s. A shop full of large appliances was somehow squeezed into the front room for a while. In 1998, Sue Cello signed a lease for Cello's Charhouse. More recently, the brightly colored building has been home to Daydreamers Cafe & Grill. (Courtesy of Betty Joe McMullen.)

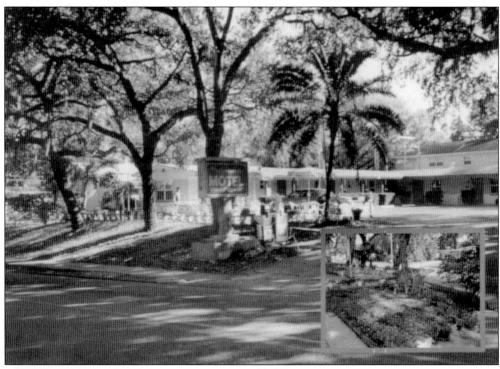

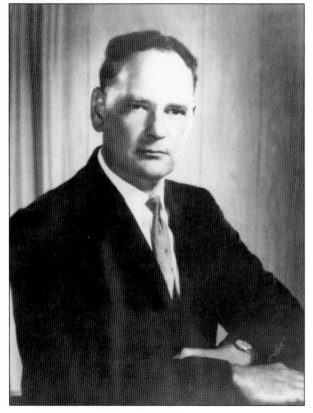

Old Florida's privately owned hotels have been disappearing over the past 30 years, but there are still two in Safety Harbor: Marbay Suites on State Road 590, north of Philippe Park, and Safety Harbor Motel on Main Street. In 1957, at the announcement of the opening of Safety Harbor's first motel, owner Pender Johnson invited the community to an open house. (Courtesy of Betty Joe McMullen.)

George McGonegal ran against previous mayor Ben Downs and real estate developer Charles Trulock in a 1964 municipal election for mayor, and McGonegal prevailed. Accusations by Trulock that Downs had been unethical in his previous term caused insults and uproar, which has not been unusual for Safety Harbor in any decade. In McGonegal's acceptance statement, he said, "I hope we can all get together and work out our problems." (Courtesy of Safety Harbor Public Library.)

The Safety Harbor Area Historical Society was very active in the 1960s and 1970s. It participated in amateur archaeological digs throughout the Pinellas Peninsula and found numerous bone fragments and artifacts dating to the Tocobaga. The spa's manager, Salu Devnani, gave the group free use of an empty Main Street storefront on the ground floor of the Silver Dome building. Arguments over the society's limited hours caused the spa management to revoke its free use. The society moved into the small one-room building at 329 Bayshore Boulevard and began working to make it a new museum. The Safety Harbor Museum and Cultural Center has come a long way since then. The museum partnered with the city, and the building underwent a massive renovation in 2012. (Above, courtesy of Kelly Griffin; below, courtesy of Heritage Village Archives and Library.)

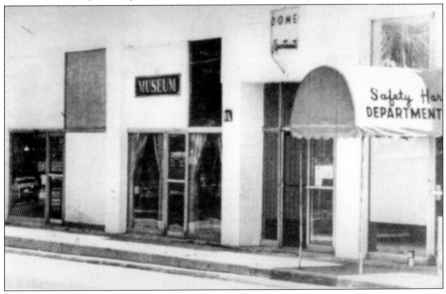

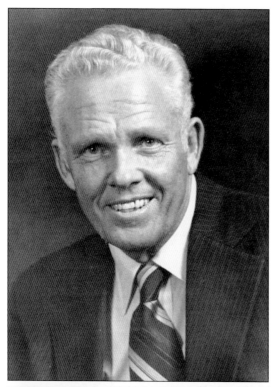

Claude Rigsby (1925–2007) and his twin brother Clyde (1925–2018) were born in their home at 706 Second Street North. Their mother died shortly thereafter, leaving their father and grandparents to raise them. As children, the twins were always causing trouble and were known for their pranks. At 17, they both ran away to enlist during World War II. When they returned home, Claude became involved in the community, serving as a police officer. Years later, he served in local politics and was elected mayor from 1972 to 1977 and from 1979 to 1981. As years passed, the police department grew corrupt, and citizens wanted it abolished. Mayor Rigsby agreed, especially because the city could not afford to fund the department. In 1976, a referendum dissolved the Safety Harbor Police Department. The Rigsby Center was named for Claude. (Left, courtesy of Safety Harbor Public Library; below, courtesy of Charles Russell III.)

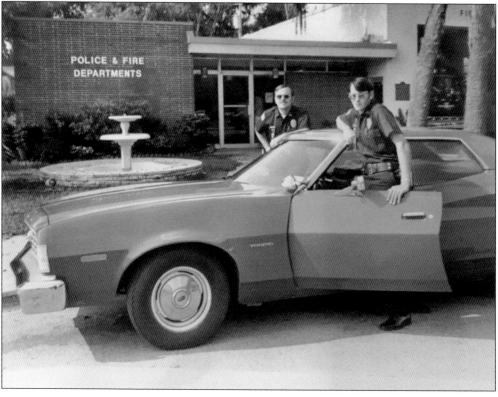

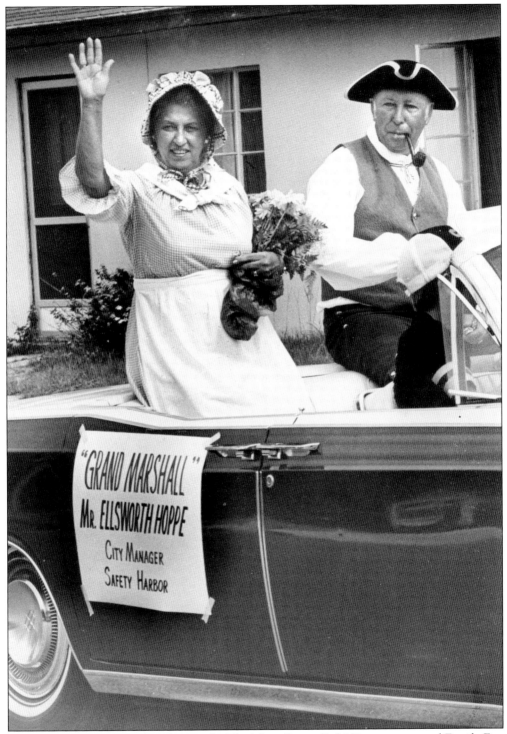

Safety Harbor has always loved a parade. The Main Street Girls' Center sponsored Family Fun Day on June 4, 1978. City manager Ellsworth Hoppe and his wife, Gwen, dressed as pioneers and tossed candy into the crowd that lined Main Street for 10 blocks. (Courtesy of *Pinellas Times*.)

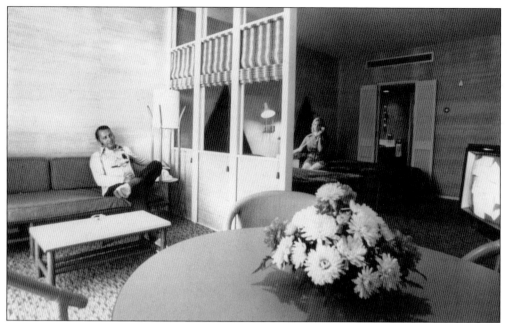

As it was in the 1940s, many guests became regulars at the spa. Dr. Baranoff died at the age of 90 in 1977, but the spa continued to flourish well into the 1980s. Unfortunately, by the late 1990s, the popularity of health resorts began to fade as tourists sought different types of vacations at Florida theme parks. (Courtesy of Heritage Village Archives and Library.)

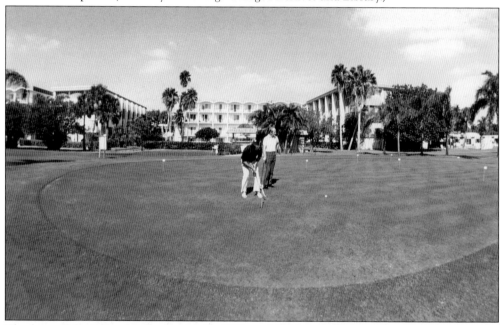

The focus of the Safety Harbor Spa in the 1970s and 1980s was all about diet, fitness, and weight loss. A 1970 brochure quoted *Mademoiselle* magazine: "A no-nonsense spa that concentrates more on health than plush. You almost have to lose weight." The spa found new popularity after several game shows gave away all-inclusive trips. Shown here is the putting green where Waterfront Park is currently located. (Courtesy of Heritage Village Archives and Library.)

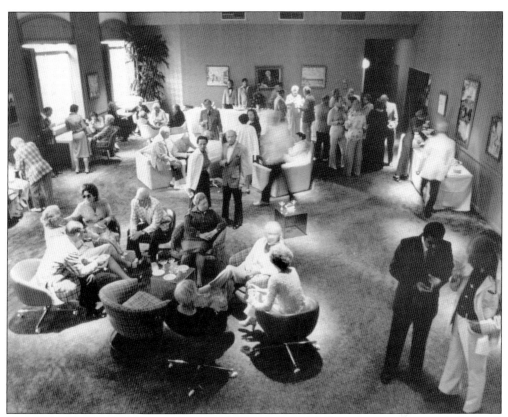

The spa lived up to the 1970s party atmosphere, too. By 1973, there were approximately 200 staff members and 400 guests at the facility. Annual profits increased from $500,000 in 1961 to over $6 million by 1981. (Courtesy of Heritage Village Archives and Library.)

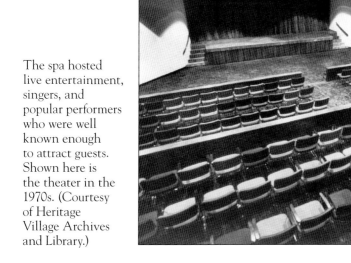

The spa hosted live entertainment, singers, and popular performers who were well known enough to attract guests. Shown here is the theater in the 1970s. (Courtesy of Heritage Village Archives and Library.)

Safety Harbor's first female mayor was Doris Jean Mellema. She was elected in 1981 and served for one year. Mellema was helpful in creating a fair deal for the Safety Harbor Area Historical Society to use a city-owned building as the new location for its museum, which is still there. (Courtesy of Safety Harbor Public Library.)

It may seem hard to believe, but Safety Harbor was not a desirable city for outsiders from the 1970s to the early 2000s. Those who called it home loved their quiet, quaint town, and many tried to halt the rampant development happening around them. Former orange groves became subdivisions, and new businesses and fast-food restaurants dotted intersections along McMullen Booth Road. Locals started calling Safety Harbor "Pinellas County's Hidden Gem." (Courtesy of Elizabeth Faubert.)

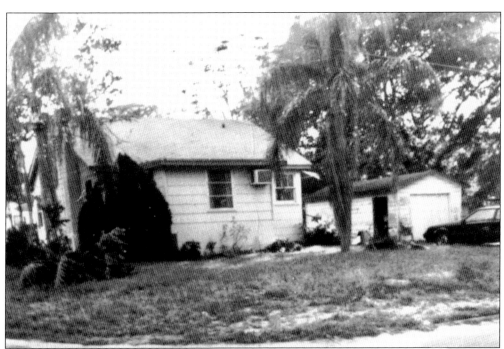

A young couple from Clearwater, Todd Ramquist and Kiaralinda, purchased a small gray house at 1206 Third Street North in 1986. Over the next decade, they would paint it, decorate it, and surround it with bowling balls. Whimzeyland, also known as the Bowling Ball House, brought thousands of visitors to experience the foundation of Safety Harbor's burgeoning art scene. For a 1999 end-of-year millennium celebration, they created a charity fundraiser to raise money for three organizations benefiting children. According to Ramquist, the artists and 100 volunteers covered the colorful house and yard ornaments in "3.5 million square inches of prismatic Mylar." Such events have always been part of the artists' lives. While Whimzeyland is still a tourist attraction, they have since created the Safety Harbor Art and Music Center at 706 Second Street North where they offer live music, classes, poetry and storytelling open mics, summer camps, and more. (Above, courtesy of Kiaralinda; right, courtesy of Holly Apperson.)

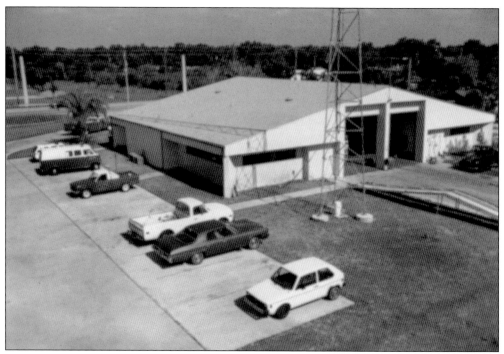

Safety Harbor's newest and second fire station, No. 53, was completed in 1983 at 3095 McMullen Booth Road. The victims of the 1917 Main Street fire would surely be amazed by how far the city has come in developing emergency services. Station No. 53 recently added an emergency operation center to provide a command center for the community in the event of a disaster. (Courtesy of Charles Russell III.)

The Kiwanis Club of Safety Harbor was chartered in 1979 and incorporated in 1980. Its focus is instilling leadership in children, building scholarship, and civic mindedness. The members engage in numerous programs at the elementary, middle, and high school levels. The group has long been a fundamental part of Safety Harbor children's development. Pictured in 1986 is a Kiwanis member presenting a Safety Harbor Library assistant with a check. (Courtesy of Safety Harbor Public Library.)

The Safety Harbor Community Center at 901 Seventh Avenue South celebrated its grand opening on Saturday, July 10, 1982, with a volleyball game between Q-105 disc jockeys and the Safety Harbor firefighters. The Countryside Cloggers and Briar Creek Twirlers entertained the crowd. (Courtesy of Safety Harbor Public Library.)

John Wilson wanted to build a liquor store on a lot he owned on Main Street. The city would not give him a permit because the property was too close to a church. The city commission re-zoned another lot owned by Wilson, and he donated his Main Street lot to the city under the condition that a future park would be named for him. This image is from the 1982 ribbon-cutting and dedication of the gazebo. (Courtesy of Safety Harbor Public Library.)

The Safety Harbor Veterans of Foreign Wars Post 10093 is at 965 Harbor Lake Court. The organization has been supporting Safety Harbor's veterans and their families since 1978. Shown is Mayor Arthur Levine honoring post commander Art Hiller at city hall. Levine was mayor from 1989 to 1993. (Courtesy of Safety Harbor Public Library.)

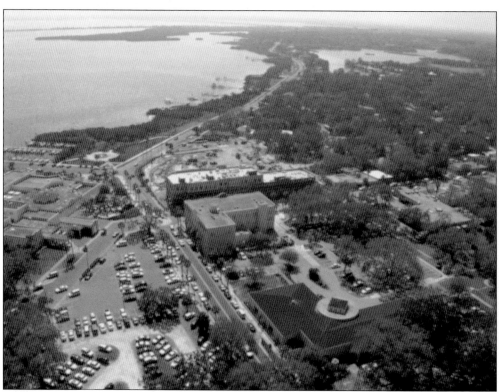

This shot of Safety Harbor was taken in the late 1990s before much of the waterfront development occurred. The new addition to the library had not yet been built, but the layout of the town was not much different than it was after the boom years. The Alden and Silver Dome buildings were replaced, but with structures that aptly hold the space of those before them. (Courtesy of Hildegard Røvde.)

Hildegard's was a small downtown beer garden owned by Hildegard Røvde, close to where the Starbucks parking lot is now. Many Safety Harbor residents first met there. Many made lifelong friends. Every type of personality hung out at Hildegard's, from bikers in leather to old-timers to young people on a date. It was torn down to make room for the current building at 100 Main Street. (Courtesy of Hildegard Røvde.)

In 2005, the McMullen Flower Shoppe was recognized for serving the community for 50 years. Now owned and run by Betty Joe "B.J." McMullen, the flower shop was started in 1955 by her mother, Netta Mae McMullen. A plaque was awarded to B.J. and her two sisters, Donna McMullen and Sandy Kane, for keeping the shop open and running for so many years. While her mother and sisters have passed away, the legacy holds true, and bouquets are still being created at the longest-running business on Main Street. (Courtesy of Betty Joe McMullen.)

Every Sunday for many years, Mattie Williams would drive the church van around her neighborhood to pick up children for Sunday school. According to her daughter Cheryl, "children of all ages held real estate in her heart." Moved by her love for the kids, between 1995 and 2005 she walked door to door with petitions to rid the Lincoln Heights neighborhood of drug dealers. Williams worked hard to make life better for children and their families, and her devotion transferred to her community service work at the Safety Harbor Neighborhood Family Center. She started volunteering there in 1996 and later became an employee. She did not stop helping, not even through four bouts with cancer. In 2008, she started the annual Christmas toy drive. The center was named for her before she passed in 2012. (Courtesy of Cheryl Williams.)

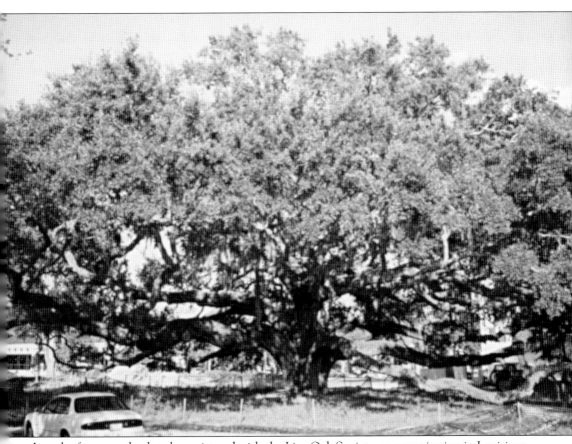

In order for a grand oak to be registered with the Live Oak Society, an organization in Louisiana that keeps track of southern grand oaks, the tree is required to have a circumference of at least eight feet. It also has to have a name. Safety Harbor's 2004 commissioners came up with a list to choose from to name the tree in front of the library that had a circumference of 19.5 feet. Suggestions included the Tocobaga Tree, the St. James Tree, the Green Springs Tree, the Hernando de Soto Tree, the Espiritu Santo Tree, the Ronald Regan Tree (to honor the former president who had just died), and, finally, at Mayor Pam Corbino's suggestion, the Baranoff Oak. At the June 21, 2004, city commission meeting, the Baranoff Oak was named and has since been recognized by the Live Oak Society. (Courtesy of Safety Harbor Public Library.)

Main Street was resurfaced in 1996. Local treasure hunters used the opportunity to bring out metal detectors to hunt for the local urban legend of "Philippe's lost treasure," which people have searched for since at least the 1940s. While no one ever admitted to finding gold, the original bricks were removed and the streets were resurfaced, which revived the look of Main Street. (Courtesy of Betty Joe McMullen.)

Netta Mae and Robert McMullen assess the scene in front of their family home, where Robert was born, as the road named for his ancestors, McMullen-Booth Road, was being widened directly in front of them in the early 1990s. (Courtesy of Betty Joe McMullen.)

Through the decades, many grown men and women have searched for treasure, believed to be buried somewhere in Safety Harbor. Instead, local children found the real treasures: arrowheads, shells, and old buttons—perfect mementoes that would provide nostalgia in later years. Reminders of Safety Harbor's past can still be discovered in random places, like this rusty truck abandoned long ago in a wooded area behind what is now The Huntingtons subdivision. Someday, today's Safety Harbor will be considered history, too. (Courtesy of Don Peer.)

DISCOVER THOUSANDS OF LOCAL HISTORY BOOKS FEATURING MILLIONS OF VINTAGE IMAGES

Arcadia Publishing, the leading local history publisher in the United States, is committed to making history accessible and meaningful through publishing books that celebrate and preserve the heritage of America's people and places.

Find more books like this at
www.arcadiapublishing.com

Search for your hometown history, your old stomping grounds, and even your favorite sports team.

Consistent with our mission to preserve history on a local level, this book was printed in South Carolina on American-made paper and manufactured entirely in the United States. Products carrying the accredited Forest Stewardship Council (FSC) label are printed on 100 percent FSC-certified paper.